IMAGES
of America

SWEDISH CHICAGO

HILDUR MARIA BERGGREN. She was born on June 24, 1906 in Sundsvall, Sweden—a town north of Stockholm. Her future husband, Waldemar Lindquist, had already immigrated to the United States in 1926, but returned to Sweden several times to visit Hildur before asking for her hand in marriage in 1931. The couple married in Sweden on February 22, 1931. Hildur and Waldemar sailed from Goteborg to New York. As the Depression raged, they took a train to Chicago where they moved into a small apartment at Damen and Lincoln Avenues. Later, the two would settle in the Andersonville neighborhood and raise two children. (Courtesy of Elsie Lindgren.)

IMAGES
of America

SWEDISH CHICAGO

Paul Michael Peterson

ARCADIA
PUBLISHING

Published by Arcadia Publishing
Charleston, South Carolina

Printed in the United States of America

Library of Congress Catalog Card Number: 2003108863

For all general information contact Arcadia Publishing at:
Telephone 843-853-2070
Fax 843-853-0044
E-mail sales@arcadiapublishing.com
For customer service and orders:
Toll-Free 1-888-313-2665

Visit us on the Internet at www.arcadiapublishing.com

This work is affectionately dedicated to my parents, Bruce and Sharon Peterson, for their constant love, unwavering support, and tireless encouragement. . .

. . . and to the memory of my Swedish grandparents—Charles and Anna Peterson—the new Vikings who placed their faith in making the American journey.

CONTENTS

ACKNOWLEDGMENTS

Because a creative work is seldom the result of one individual effort, I would like to extend my gratitude to the collection of folks who offered their time, resources, and expertise. Among those who informed and contributed to *Swedish Chicago* through their unselfish generosity of knowledge, photographs, and family anecdotes, I would especially like to thank: Clarence and June Anderson, Larry Anderson and wife Patty Rasmussen, Marcia Anderson, Pehr Bolling, Marti Corcoran, Bruce DuMont, Susan Erickson, Andy Freborg, Ray Helgeson, Elizabeth and Ralph Johnson, Rick Kogan, Elsie and John Lindgren, Roy Lundberg, Pearl Magnuson, Madeline Mancini, Vera Nelson, Ann-Britt Nilsson, Ann–Mari Nilsson, Annette Peterson, Bruce and Sharon Peterson, Evelyn Reese, Miriam Seaholm, Gail and Pat Shaw, Charles R. Smith, and Ingvar Wikstrom.

Several institutions were also of great help during the course of this project and to them I am deeply indebted: Ellen Engseth, director of Archives and Special Collections at North Park University, Chicago; Kerstin Lane, director of the Swedish American Museum Center in Chicago, without whose permission to access the museum, knowledge of the Swedish community, and willingness to inform this project, *Swedish Chicago* would not have been possible; and, the Chicago Historical Society.

Special thanks to my friend and mentor, Mario Lopez, for his early encouragement; Richard Francis Tracz, for his faith in my scholarly abilities; David and Beth Peterson, Alex Peterson, and Nicole Peterson, for family support; Rahan Ali, for his lifelong friendship; and Joan Bowers for her unselfish love and support throughout the journey of this project. Also, a thousand thanks to my editor, Samantha Gleisten, and the entire staff of Arcadia Publishing who work thanklessly behind the scenes to make these books possible.

Finally, sincere appreciation to you, the reader, for your interest in this text. It is my firm hope that this book will delight and inform your sense of Chicago's Swedish community as you reflectively journey through the century of photographs contained in these pages.

INTRODUCTION

Swedish Americans who call Chicago their home are the inheritors of a rich and historic legacy. The Chicago with which we are familiar today in the infancy of the 21st century remains pointedly different from the hypnotic metropolis that offered Swedes a home between the 1860s and the 1930s. Delayed industrialization, widespread crop failures, and an overpopulated countryside all uniquely played a role in the massive Swedish emigration that categorized the last 50 years of the 19th century and the first 20 of the century following. Especially worth noting is a population statistic to which many may not be privy: at the turn of the 20th century, 67 years after Chicago was incorporated as a town, the city's Swedish population was second only to that of Stockholm—the capital of Sweden.

The seven chapter book you are about to explore only serves as a minor footnote to the vast mosaic of Swedish history and culture. A fundamental lack of time and resources precluded the opportunity to examine the Swedish community with the deliberate and detailed eye they so richly deserve. It is hoped that the photographs, documents, and histories presented within this visual panorama will whet the future appetites of the scholar, the newly-arrived immigrant, or the fifth generation Swedish-American who desires to embrace the rich heritage Swedish immigrant history and culture have to offer.

THE STATUE OF LIBERTY. A heartwarming scene for many immigrants arriving at our shores, Lady Liberty symbolized promise to those in search of opportunity and a new life in America. (Courtesy of Paul Michael Peterson.)

STEAMSHIP TRAVEL FROM SWEDEN. In our present age of computer enhancements and high-tech special effects, one might marvel at the daunting realism of the scene pictured above. As this photo illustrates, traveling to a new land meant not only leaving behind one's family, but also facing at least a week's journey on the icy waters of the Atlantic. (Courtesy of Elsie Lindgren.)

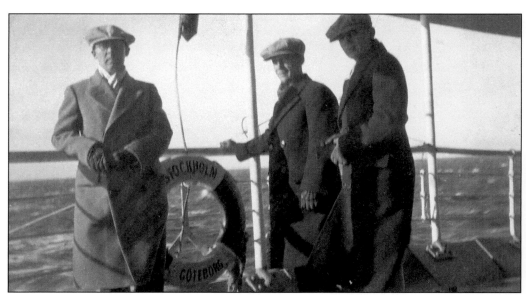

EN ROUTE TO AMERICA. Brothers Gosta Lindquist, Ernie Lindquist, and Waldemar Lindquist pose aboard the *M.S. Stockholm I*—one of four ships belonging to the Swedish American line. (Courtesy of Elsie Lindgren.)

One

THE EARLY YEARS

Leaving a large farming family to immigrate to a metropolis in North America could prove especially distressing to those who came from a land where working the soil was as natural as breathing. But the early Swedes were Vikings—explorers in search of new lands and welcoming opportunities much like the emigrants who sailed to America centuries later. In *Chicago, the Essence of "the Promised Land"*, Ulf Beijbom reports, "Of the 1.2 million Swedes who emigrated between 1850 and 1920, approximately every fourth one came from a town." This alters the traditional notion that casts many Swedish emigrants as rural types. Because the intensity of Swedish emigration remained stronger in the towns rather than in the countryside, Beijbom notes, the Swedish desire to occupy cities testifies to the importance of urbanization.

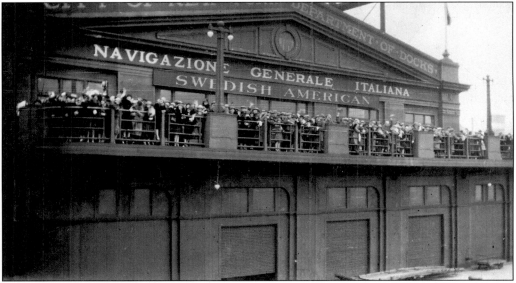

CITY OF NEW YORK, DEPARTMENT OF DOCKS. While those portrayed here are probably exhausted from their long voyage, one can sense the gaiety and anxious excitement on the faces of these Swedish immigrants as they await processing at the port of arrival. (Courtesy of Elsie Lindgren.)

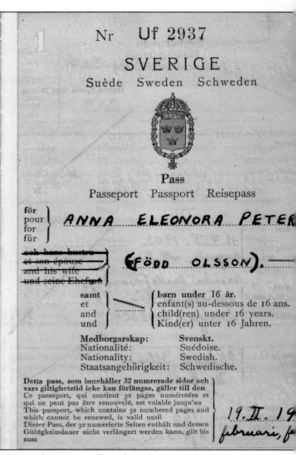

Att observera.

Passet är en viktig handling, som bör omsorgsfullt bevaras.
~~e~~dan giltighetstiden utlöpt, skall detta pass återställas i samband
~~m~~ed ansökan om nytt pass. Sker så ej, uppstå svårigheter erhålla
~~n~~ytt pass.

Missbruk av passet är straffbart.

Medborgarskap. Svensk medborgare, som är född utomlands
~~o~~ch aldrig haft hemvist, fullgjort värnplikt eller genomgått skol-
~~u~~tbildning i Sverige, förlorar i de flesta fall automatiskt det svenska
~~m~~edborgarskapet vid fyllda tjugotvå år. Konungen må dock medgiva
~~de~~ss bibehållande. För sådant ändamål bör ansökan ingivas till
~~b~~eskickning eller konsulat i god tid före uppnådda tjugotvå år.

Passinnehavare, som mera stadigvarande vistas i utlandet, upp-
~~m~~anas i eget intresse att anmäla sin adress hos Kungl. Maj:ts
~~b~~eskickning i landet eller hos närmaste svenska konsulat.

Passinnehavare tillrådes att här nedan anteckna namn och
~~b~~ostadsadress.

Anna Eleonora Peterson

2248 Addison st

Chicago Ill.

Nr **Uf 2937**

SVERIGE

Suède Sweden Schweden

Pass

Passeport Passport Reisepass

för
pour ANNA ELEONORA PETER
for
für

~~och hans hustru~~ **(FÖDD OLSSON).**
~~et son épouse~~
~~and his wife~~
~~und seine Ehefrau~~

samt) barn under 16 år.
et) enfant(s) au-dessous de 16 ans.
and) child(ren) under 16 years.
und) Kind(er) unter 16 Jahren.

Medborgarskap: Svenskt.
Nationalité: Suédoise.
Nationality: Swedish.
Staatsangehörigkeit: Schwedische.

Detta pass, som innehåller 32 numrerade sidor och
vars giltighetstid icke kan förlängas, gäller till den
Ce passeport, qui contient 32 pages numérotées et
qui ne peut pas être renouvelé, est valable jusqu'au
This passport, which contains 32 numbered pages and
which cannot be renewed, is valid until
Dieser Pass, der 32 numerierte Seiten enthält und dessen
Gültigkeitsdauer nicht verlängert werden kann, gilt bis
zum

19. II. 19
februari, f

A TYPICAL SWEDISH PASSPORT. Utilized by the author's grandmother for vacation purposes years after her initial arrival to America, this passport reflects an image most common to those who traveled the Swedish American line. (Courtesy of Bruce Peterson.)

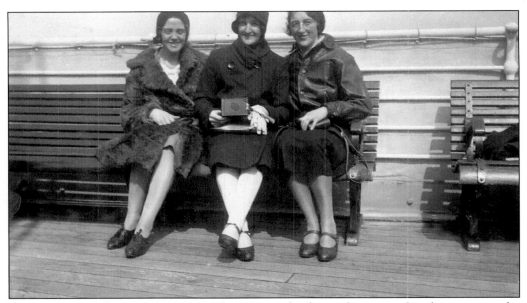

CROSSING THE ATLANTIC. Anna Olson (center), the author's grandmother, crosses the Atlantic with two friends as they make their way to the United States. Shortly after arriving in America, she would travel to Chicago, find work in a bakery, and later marry Charles Peterson with whom she had two children—Bruce and Evelyn. (Courtesy of Bruce Peterson.)

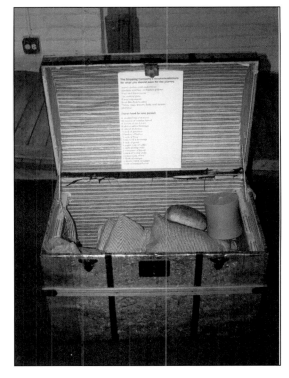

A SWEDISH TRUNK. Travel clothes, blankets, cooking pots, herring, and potatoes were just some of the items typically found in the trunks of Swedish emigrants. Any belongings or necessities to which one desired access—both during the trip and after arriving in the United States—had to fit in this archaic form of luggage. (Photograph by Paul Michael Peterson; courtesy of Swedish American Museum Center.)

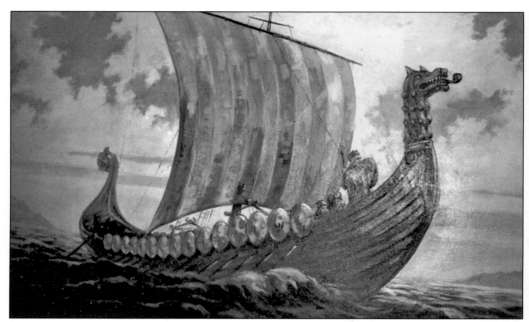

PAINTING OF A VIKING SHIP. Although not a member of the Swedish American line, the early Viking craft illustrated above is an impressive, if less luxurious form of travel. This piece, taken from a three piece mural restored by Edward Olson, was once displayed at the Swedish Club on LaSalle Street before its arrival at the Swedish American Museum Center where it hangs prominently today. (Photograph by Paul Michael Peterson; courtesy of Swedish American Museum Center.)

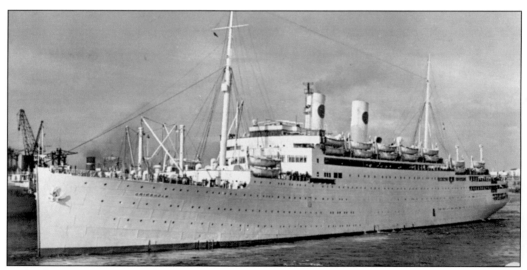

M.S. GRIPSHOLM. According to information gathered by the Swedish American Museum Center, the M.S. Gripsholm was the third ship in the Swedish American line, but the first to be built for the SAL rather than purchased from another steamship company. Because the U.S. government initiated an immigrant quota system in 1924, the Gripsholm was employed more as a cruise ship than as an emigrant transport. The first North American diesel engine motor ship (as opposed to her steamship predecessors), the Gripsholm's smokestacks were merely decorative. (Postcard courtesy of Paul Michael Peterson.)

Middag

❧

Smör Bröd Ost Aptitbitar
Räkor Pressylta Rödbetor Salami
Potatissallad

———

Kalvsauté Ärter Morötter Saltgurka
Kokt Potatis

———

Äpple Apelsin

———

Kaffe - Té

❧

Kl. 4 fm. ställas klockorna tillbaka 30 minuter

Dinner

❧

Butter Bread Cheese Tidbits
Shrimps Brawn of Pork Red Beets
Salami Potato Salad

———

Veal-sauté Peas Carrots Cucumber
Boiled Potatoes

———

Apple Orange

———

Coffee - Tea

❧

At 4 a. m. clocks will be set back 30 minutes

TOURIST
M. S. Gripsholm, Thursday, October 28, 1948

SWEDISH AMERICAN LINE MENU. This tourist menu from 1948 reflects the culinary selections for the dinner or "middag" meal. (Courtesy of Bruce Peterson.)

EBBA THUFVESSON. She sailed to America on the last boat out of Norway before 1940. Her husband, Alf (pictured in the back row, center, in the photograph below), traveled from Sweden through Russia and Siberia on a Japanese freighter before reaching America where he worked as a 3-D engraver. Ebba and Alf's daughter, Susan Erickson, presently owns and operates the Sweden Shop on Foster Avenue in Chicago. (Courtesy of Susan Erickson.)

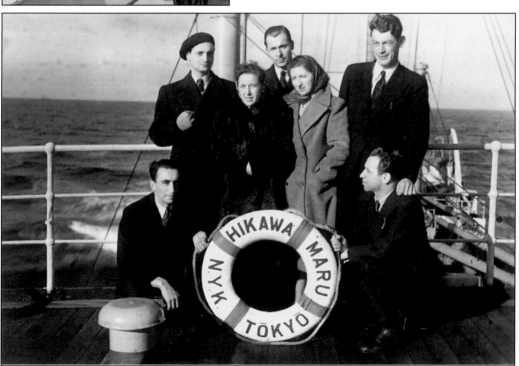

ALF THUFVESSON. He stands in the back row, center. (Courtesy of Susan Erickson.).

Two

FAMILY LIFE

If overpopulation stifled opportunity in the Swedish countryside, it seems only natural that 2 or 3 children from a family of 10 to 13 would make the journey to North America. Many immigrants left Sweden never to return, their only communiqué with the family left behind through letters and postcards. Marriage and children offered security from loneliness and a form of success for the immigrant who arrived with very little money and limited resources. The family could provide an emotional stronghold, as well as the opportunity to continue the family name in a new land.

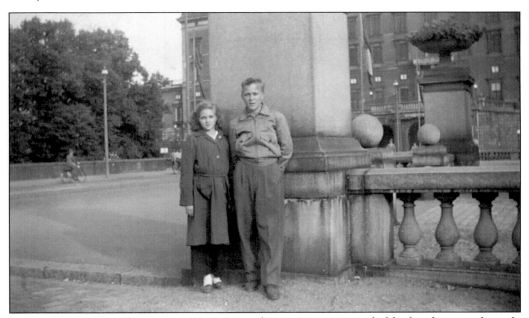

EVELYN AND BRUCE PETERSON, 1948. Here the younger sister and older brother pose happily in Stockholm while visiting Sweden for the first time with their mother in 1948. (Courtesy of Bruce Peterson.)

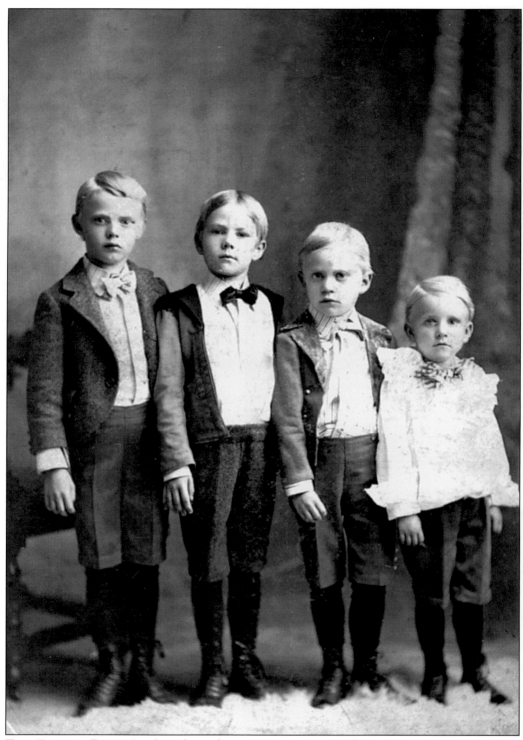

THE FRIBERG BOYS. In this photo from 1900 are George (born August 6, 1893), Dave (born July 11, 1894), Carl—later known as "Tully" (born May 17, 1896), and Gustave (born April 3, 1898). (Courtesy of Andy Freborg.)

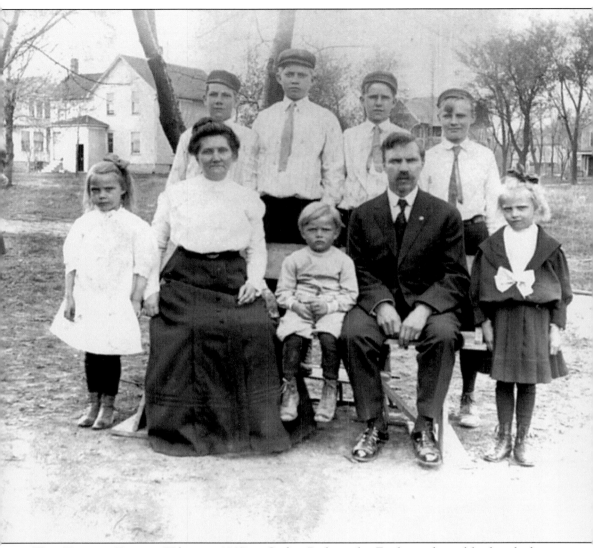

THE FRIBERG FAMILY. Taken in 1907 at Ogden Park in the Englewood neighborhood, this photo shows: (front row) Dagmar, Anna, Stanley, Carl (later Charlie), and Hortense; (back row) Waldemar, Carl (Tully), Gustave, and Goran. The Friberg's, whose name gradually evolved and changed to "Freborg," lived in Swedish Englewood from 1888–1940 and were founding members of Bethel Lutheran Church. (Courtesy of Andy Freborg.)

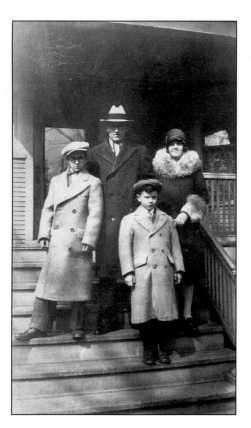

ERICK ANDERSON (1889-1959) WITH FAMILY. Pictured here with his wife Anna and sons Herbert and Clarence, Erick immigrated to the U.S. in 1909 from Dalarna, Sweden. He became a U.S. citizen on September 22, 1915, and settled in the Ravenswood area in approximately 1917. (Courtesy of Clarence Anderson.)

ERNEST A. ANDERSON (1889–1974) WITH FAMILY. This 1924 photograph shows Ernest with wife Mathilda, and children Earl and June. Ernest emigrated from Halland, Sweden, in 1909. He later settled in the Portage Park area with his family. Although Erick Anderson (pictured above) and Ernest Anderson (pictured right) were not related, Erick's son Clarence married Ernest's daughter June in 1945. After nearly six decades of marriage, Clarence and June now happily reside in Luther Village in Arlington Heights, Illinois. (Courtesy of June Anderson.)

CHARLES E. SMITH WITH FAMILY AND FRIENDS. Charles (front left) is seen here with son Charles R. Smith, wife Anna (second row, second from left), and other Swedes in Lincoln Park. After arriving in the U.S. in 1888 at the age of 19, Charles worked as an independent contractor and was highly active in the Svithiod Lodge. (Courtesy of Charles R. Smith.)

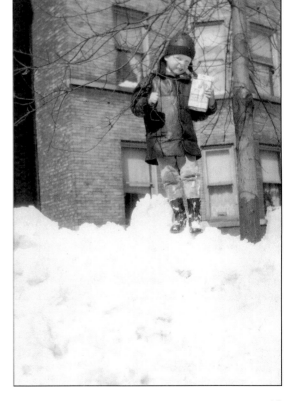

A MINI-VIKING IN CHICAGO. Charles R. Smith, playfully adorned with Viking helmet, frolics in the winter snow on Newport Avenue in March of 1930. Reportedly, his father changed the family's original Swedish surname—which remains unknown—to "Smith" in an attempt to avoid outside judgment as a new immigrant. (Courtesy of Charles R. Smith.)

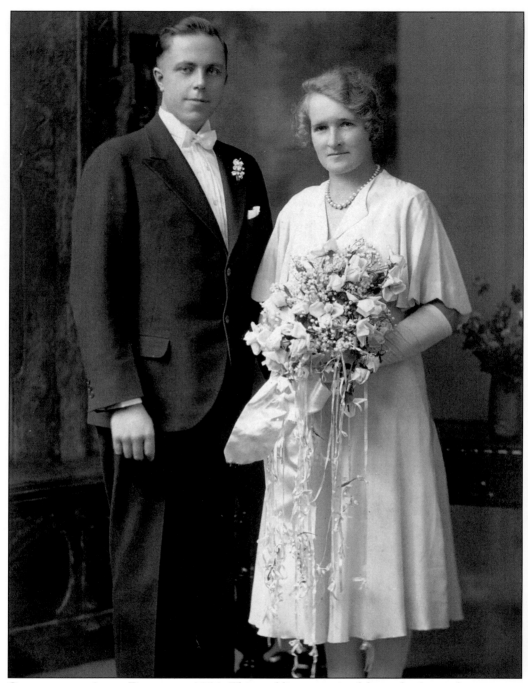

CHARLES AND ANNA PETERSON, 1931. This wedding portrait of the author's grandparents was taken in October of 1931. "Charlie," as he was affectionately known, was born Karl Helgaard Emmanuel Pettersson on July 27, 1897. At the age of 25, he immigrated to the U.S. by way of the Drottningholm on February 6, 1923 from Yterlanas, Sweden. Anna Eleanor Olson, later Anna Peterson, was born in Arvika, Sweden on August 11, 1903. The couple had two children—Bruce, born in 1934; and Evelyn, born in 1937. The family settled in a three flat apartment at 2248 W. Addison Street on the city's north side. (Courtesy of Evelyn Reese.)

RELAXING AT DIAMOND LAKE, 1936.
Anna Peterson (from left) with son Bruce,
unidentified friend, and husband Charlie
escape city life for a few days in 1936.
(Courtesy of Bruce Peterson.)

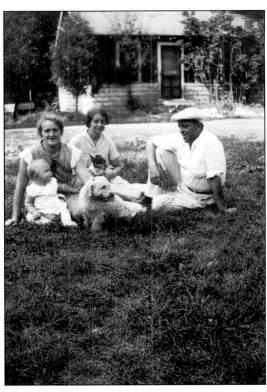

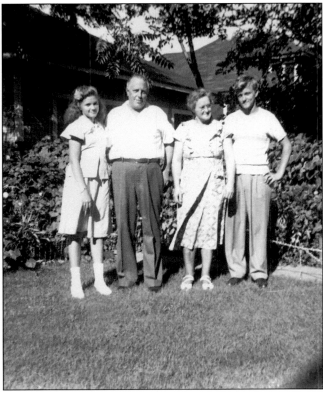

THE PETERSON FAMILY,
c. 1950. Evelyn, Charlie,
Anna, and Bruce pose for a
family photo in the yard of
their home at 2248 W. Addison
Street on a beautiful spring day.
(Courtesy of Bruce Peterson.)

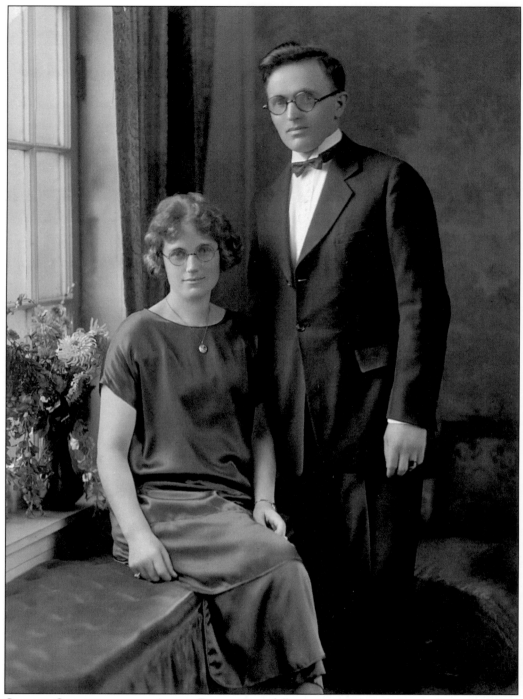

GUSTAF CARLFELDT AND AGNES BLOM. Gustaf (born in 1893) and Agnes (born in 1898) married in 1925. Gustaf worked as a physical therapist, serving as a personal masseur to actress Gloria Swanson. (Courtesy of Elizabeth Johnson.)

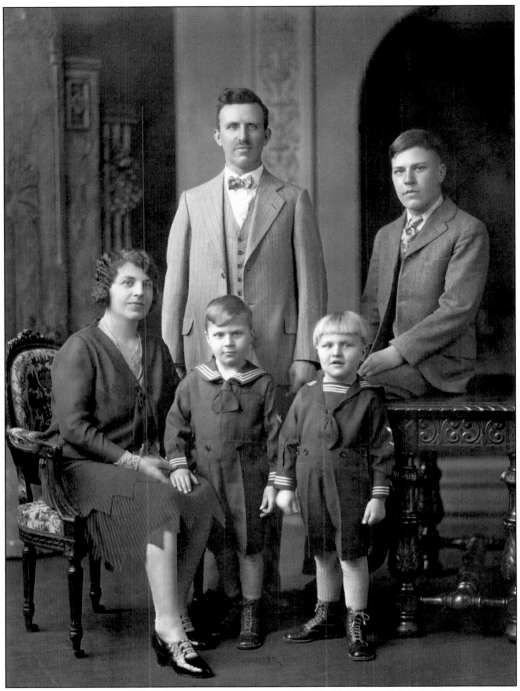

THE LINDOR JOHNSON FAMILY. Pictured here are (from left) Elin and Lindor Johnson, with sons Stanley, Ralph, and Clarence. Lindor and his family settled in the West Rogers Park neighborhood. (Courtesy of Ralph Johnson.)

EDITH AND RUDY EHRLIN. The romantic nature of this happy photograph is evident from the look on Rudy Ehrlin's face as he gazes lovingly at his wife, Edith. Here, they enjoy a warm summer day at one of Chicago's beaches. (Courtesy of Annette Peterson.)

RUDY EHRLIN AND DAUGHTERS. This August 1938 photo shows Rudy Ehrlin with daughters Annette and Peggy. As an adult, Peggy cultivated a fondness for gardening and unselfishly devoted herself to many volunteer gardening projects. Annette continues to enjoy semi-retirement after a successful career in banking and finance. (Courtesy of Annette Peterson.)

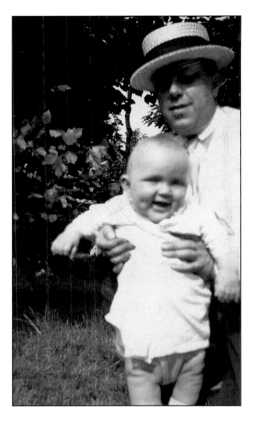

FATHER AND SON, C. 1935 AND 1954. A young Charles Peterson with son Bruce in the spring of 1935 contrasted with a more mature father and son, shortly after Bruce's enlistment in the army in the fall of 1954. (Courtesy of Paul Michael Peterson.)

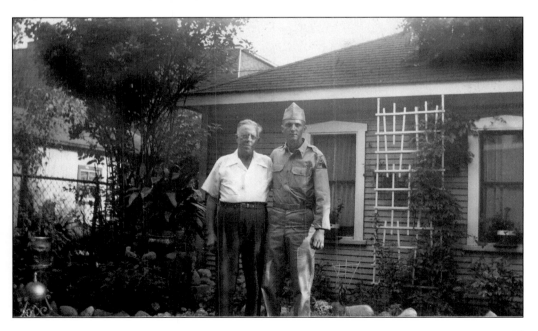

BILL THEGERSTROM WITH BROTHER (*above*) **AND WIFE** (*right*). Like many Swedish immigrants of his day, Bill found work as a house painter. Note the serious pose above as he stands by his younger brother Martin (above) versus the more playful pose captured in the photograph below where he poses with his wife. (Courtesy of Bruce Peterson.)

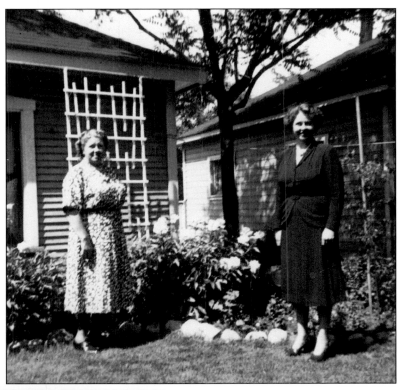

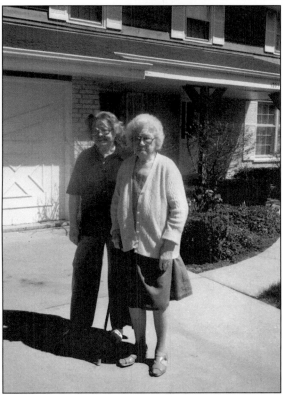

SELMA THEGERSTROM WITH
DAUGHTER DOROTHY, C. 1948
(above) AND 1988 (below).
Selma Thegerstrom arrived in the
United States before her brother,
Charles Peterson. In a family of 13
children, Selma and Charles were two
of four from the family to immigrate to
the U.S. Although she and her family
lived in Chicago, she eventually settled
in Northbrook away from the bustle of
the city. (Courtesy of Bruce Peterson.)

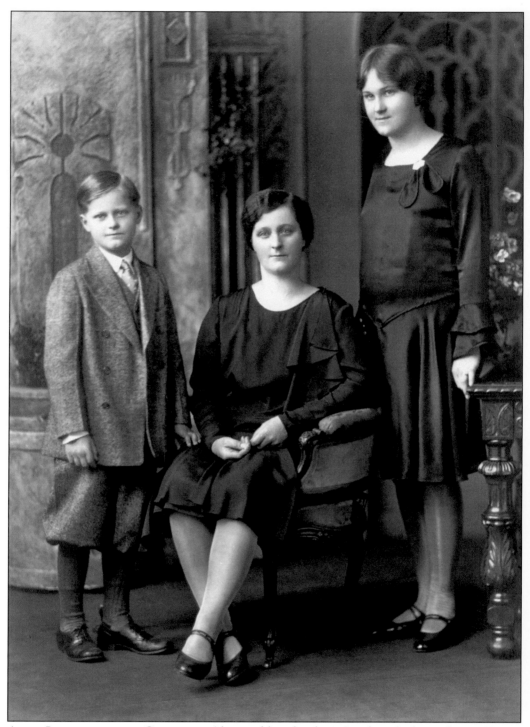

ALICE JOHANSON WITH CHILDREN. Alice and her daughter Carol worked together in Hanna Persson's Bakery located in the 3200 block of N. Sheffield Avenue. Alice's son, Gustav, was killed in action in World War II. Carol eventually married Erik Anderson and had two daughters. Years later, she and her husband retired to Arizona. (Courtesy of Evelyn Reese.)

ALF THUFVESSON, C. 1947.
Alf and daughter Susan (Erickson) enjoy time together as they vacation in Sister Bay, Wisconsin. One might speculate that vacations spent in rural, bucolic settings reminded Swedes of home. (Courtesy of Susan Erickson.)

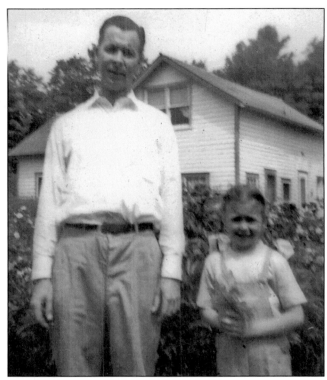

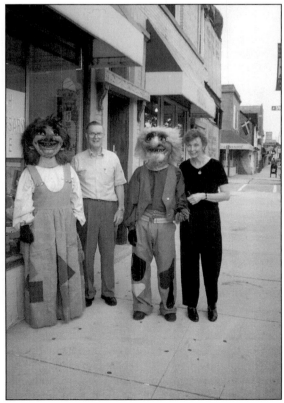

SUSAN ERICKSON WITH HUSBAND OLLE AND TWO FRIENDS. Proudly standing in front of The Sweden Shop where one can find myriad Scandinavian treasures, Susan Erickson and husband and celebrate the store's anniversary. (Courtesy of Susan Erickson.)

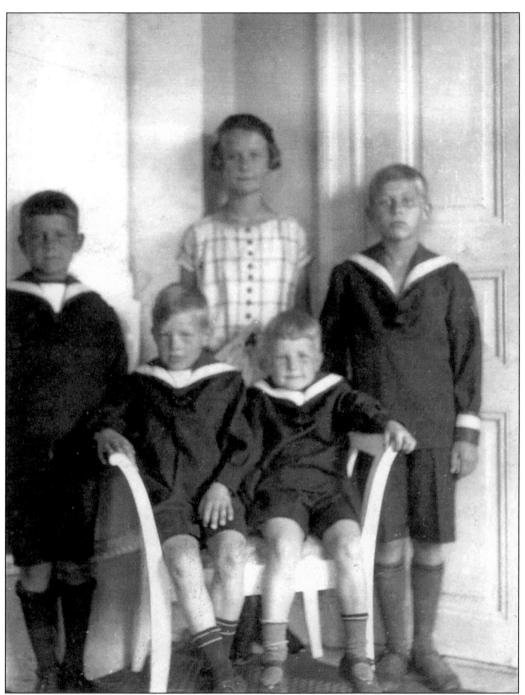

THE BOLLING CHILDREN, 1927. An early photo dating from 1927 shows Bolling children Hans, Pehr, Bengt, Carl, and Martha in Mariestad, Sweden prior to their immigration to America. Otto Bolling, along with his two eldest children, Martha and Carl, left Sweden for America in 1929 with the hope of finding work. The following year, his wife Marie, and sons Pehr, Hans, and Bengt arrived in Chicago where the family settled in the Lakeview neighborhood. (Courtesy of Pehr Bolling.)

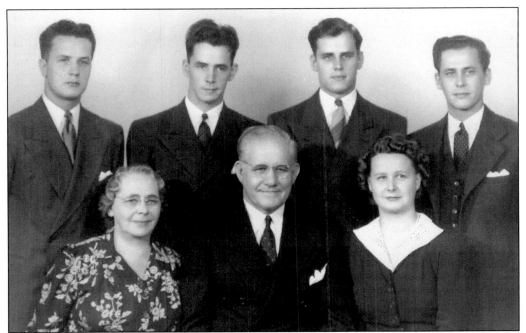

BOLLING FAMILY PHOTO, 1940. Shown here in a family portrait years after their arrival to the U.S. are, from left to right: (top row) brothers Bengt, Hans, Pehr, and Carl; and (front row) mother Marie, father Otto, and sister Martha. (Courtesy of Pehr Bolling.)

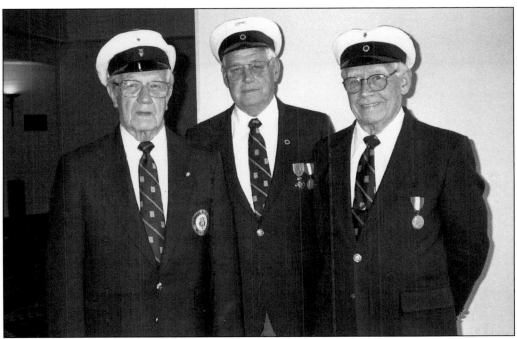

BOLLING BROTHERS, C. 1990S. Studying the portrait from 50 years earlier (shown above), one might note—despite the passing of five decades—the similarities in the facial expressions of brothers (from left) Bengt, Pehr, and Hans Bolling. (Courtesy of Pehr Bolling.)

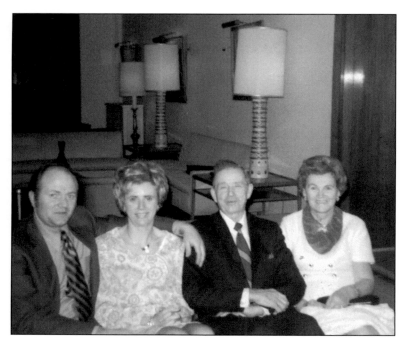

ELSIE AND JOHN LINDGREN. The 1971 photo above shows John and Elsie Lindgren, along with Elsie's parents, Waldemar and Hildur Lindquist. Despite emigrating from Sweden and arriving in America during the height of the Depression, Waldemar found work as a painter. In the photo below, taken 10 years later, Elsie and John prepare the Christmas smorgasbord before playing host to soon-to-be-arriving family members. (Courtesy of Elsie Lindgren.)

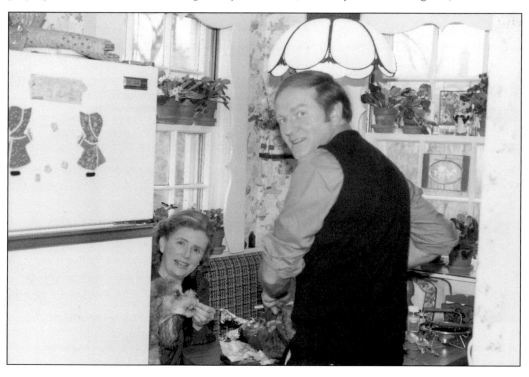

Three

WORK

The great majority of Swedes who arrived in America secured jobs as laborers—some skilled, some unskilled. Although commonly viewed as farmers and rural pioneers, many who settled in Chicago worked as painters, bricklayers, carpenters, machinists, bakers, and gardeners who traded their sweat for a day's wages to support themselves and their families. Within the confines of the city, it was common to hear the saying, "The Swedes built Chicago." Other Swedes, possessing the strong work ethic for which Swedes are known, as well as the necessary business acumen, achieved a higher standard of living, and in some cases, made names for themselves that continue to resonate with us today: Andrew Lanquist, Carl Linnaeus, Pehr Samuel Peterson, and Charles Walgreen.

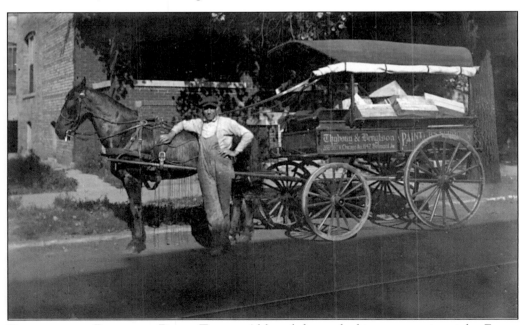

THYBONY AND BENGTSON PAINT TRUCK. Although he worked in many various jobs, Ernest A. Anderson found employment with the Thybony and Bengston Paint Company in 1920. He worked six days per week from 7 a.m. until 7 p.m. for a weekly salary of $27. Ernest retired 48 years later in 1968. (Courtesy of June Anderson.)

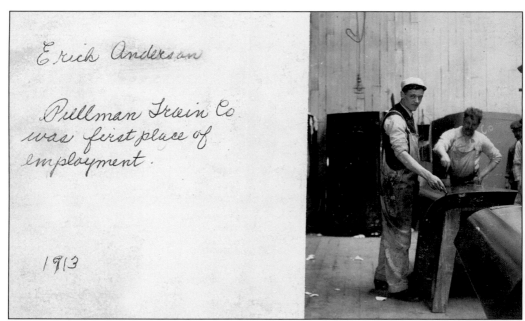

The handwritten text on the photo reads:

Erick Anderson

Pullman Train Co. was first place of employment.

1913

ERICK ANDERSON, 1913. Upon arriving in America, Erick Anderson initially found work with the Pullman Train Company. Note the somewhat harsh realism of the photo as Erick receives what appears to be training from a veteran supervisor. (Courtesy of Clarence Anderson.)

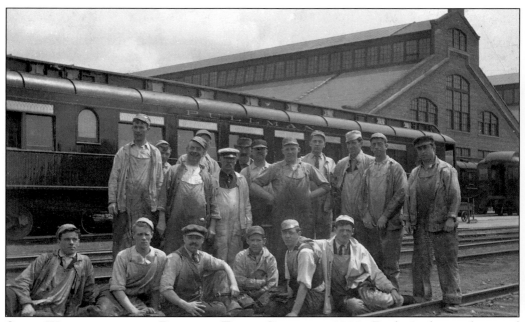

CREW WORKING AT THE PULLMAN TRAIN COMPANY, 1913. Erick Anderson (pictured front right) is shown at age 24. Erick later worked as a painter and decorator on the North Shore, a profession into which his sons Herb and Clarence would later follow. (Courtesy of Clarence Anderson.)

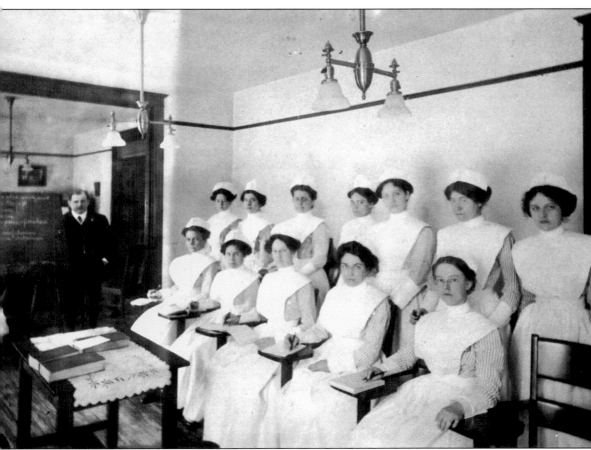

NURSING STUDENTS, SWEDISH COVENANT HOSPITAL SCHOOL OF NURSING, C. 1914. (Courtesy of Covenant Archives and Historical Library, located at North Park University, Chicago, Illinois.)

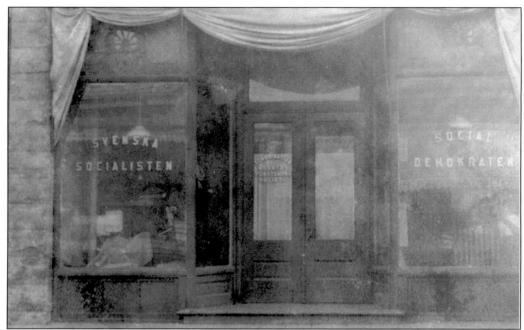

SWEDISH AMERICAN NEWS. This undated photo from the early 1900s illustrates the exterior of the *Svenska Socialisten* and *Social Demokraten* offices in Chicago. According to information from the Swedish American Museum Center, "over 1,500 Swedish-American newspapers came and went between 1850 and 1940." Today, only four Swedish American newspapers continue to be published in the U.S. (Courtesy of Swedish-American Archives of Greater Chicago, located at North Park University, Chicago, Illinois.)

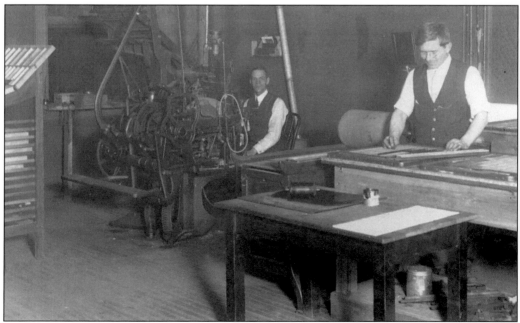

SVENSKA SOCIALISTEN PRINT SHOP. (Courtesy of Swedish-American Archives of Greater Chicago, located at North Park University, Chicago, Illinois.)

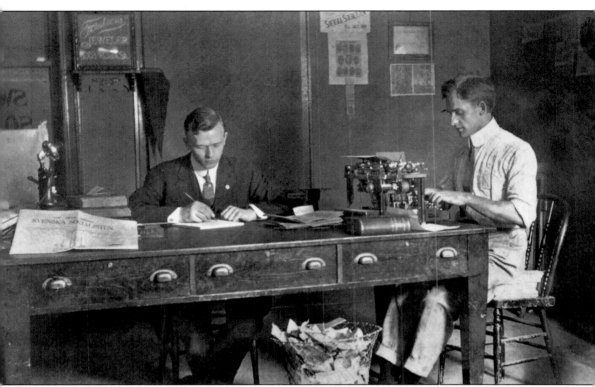

***Svenska Socialisten* OFFICE, 1912.** Henry Bengston (left) and Gideon Edberg work tirelessly on an issue of the *Svenska Socialisten* newspaper. In our modern age of computer word processing and high speed Internet access, one can only begin to surmise the enormity of their daily tasks. (Courtesy of Swedish-American Archives of Greater Chicago, located at North Park University, Chicago, Illinois.)

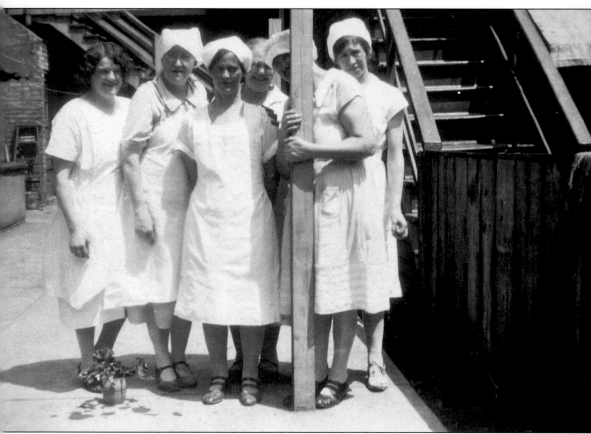

FEMALE WORKERS FROM HANNA PERSSON'S BAKERY, C. 1930S. Located in the 3200 block of N. Sheffield Avenue, Hanna Persson's Bakery employed many young women from Sweden—a fact evidenced by this photo taken outside the store in the 1930s. The female employees, who lived in an apartment above the bakery, maintained a strict 10 p.m. curfew so that they could rise by 4 a.m. and begin the day's baking. (Courtesy of Bruce Peterson.)

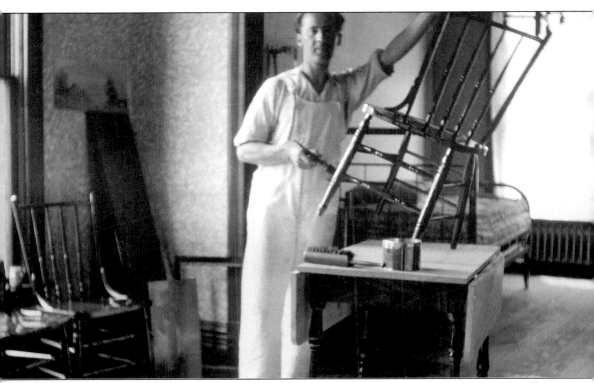

GOSTA LINDQUIST. Gosta Lindquist, well known for his affable nature, found work as a painter after arriving in the U.S. with brothers Ernie and Waldemar. In this photo, he takes a momentary pause while varnishing a set of dining chairs. (Courtesy of Elsie Lindgren.)

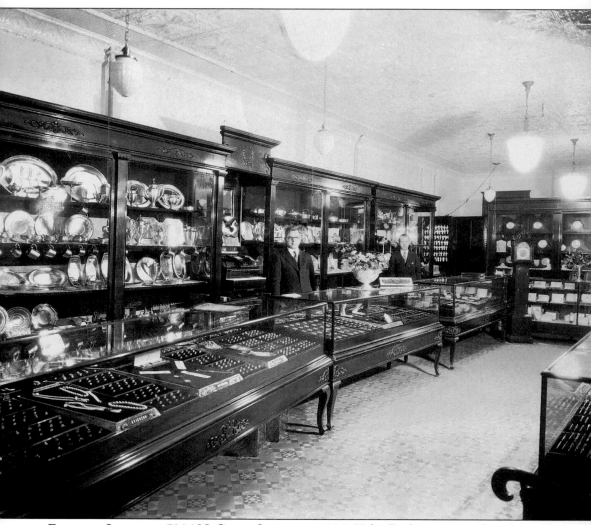

ERICKSON JEWELERS, 5304 N. CLARK STREET, C. 1930. Helge Erickson remained in the jewelry business in the Edgewater (Andersonville) neighborhood for 45 years. Although the business mainly consisted of selling many exclusive lines of jewelry, watches, and silver, they also repaired jewelry and watches. (Courtesy of Marcia Anderson, Pearl Magnuson, and Miriam Seaholm.)

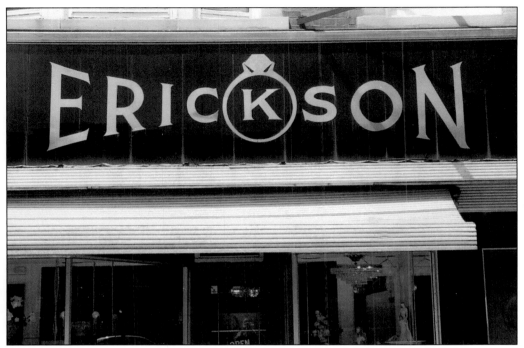

ERICKSON JEWELERS, C. 2003. The outside of the store, as it appears today, has been noted as a fine example of Art Deco style. (Courtesy of Marcia Anderson, Pearl Magnuson, and Miriam Seaholm.)

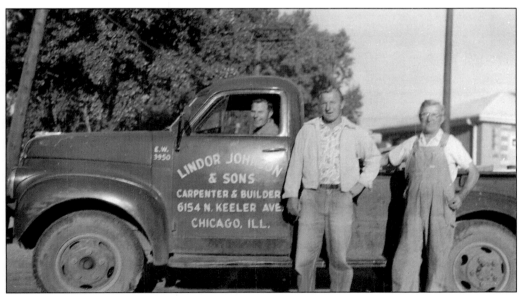

LINDOR JOHNSON AND SONS, CARPENTER AND BUILDER. Not every Swede who worked with his hands was a jeweler. Lindor Johnson, along with sons Clarence, Ralph, and Stanley spent many successful years in the construction trade—a noble profession for which many Swedes were known. (Courtesy of Ralph Johnson.)

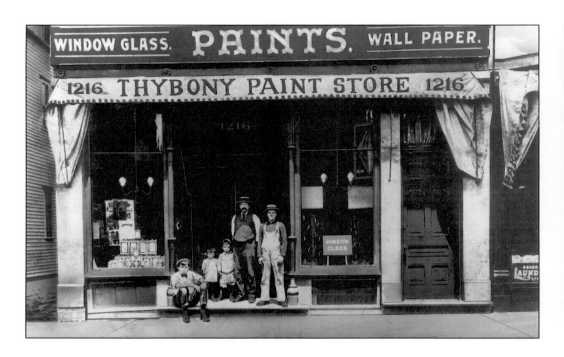

THYBONY PAINT COMPANY. William Thybony, a Swedish immigrant and skilled painter who arrived in the U.S. in 1886, opened his paint store on the north side of Chicago. In the photo above, taken at the turn of the century, William stands in front of his second store with his three sons and a store clerk. The photograph below further illustrates that it pays to advertise. (Courtesy of Jim Thybony.)

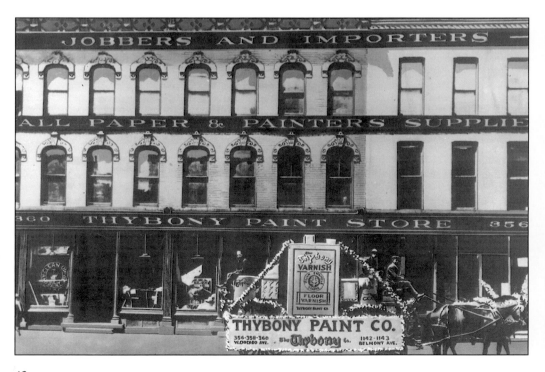

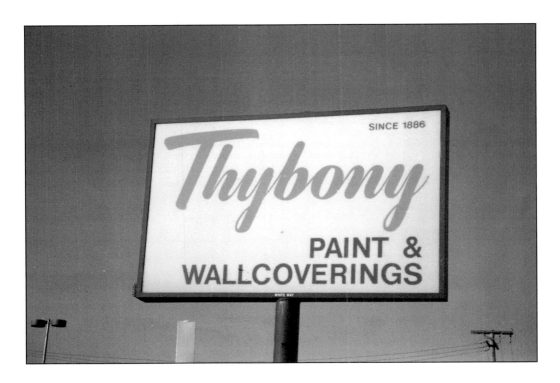

THYBONY PAINT AND WALLCOVERINGS, 2003. Four generations later, Jim Thybony— William's grandson—has continued to build Thybony Paint, Wallpaper and Home Interiors into a leading retailer of paints, wallpapers, and window fashions throughout the Chicago area. (Photographs by Paul Michael Peterson.)

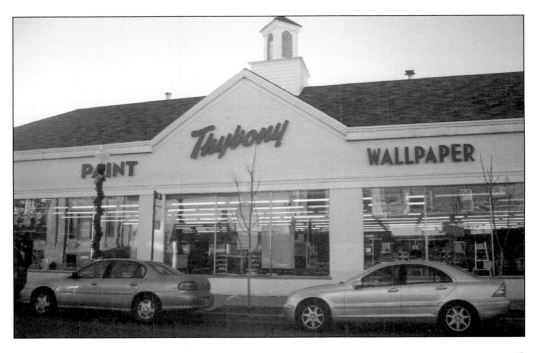

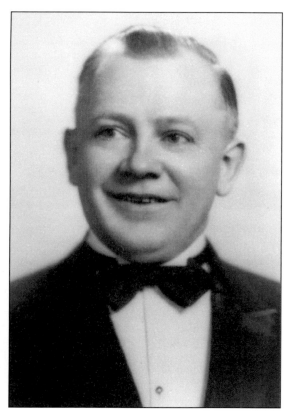

MR. JOHN NELSON. Before his passing in 1967, John Nelson operated the Nelson Funeral Chapel for many years. His father, August Nelson, started the business after emigrating from Sweden in 1899. Under the guidance of August Nelson, Nelson Funeral Chapel won a reputation as one of the best undertaking establishments among the Swedish people of Chicago. (Courtesy of Mrs. Vera Nelson.)

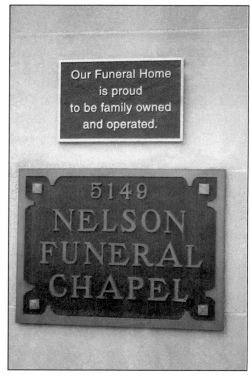

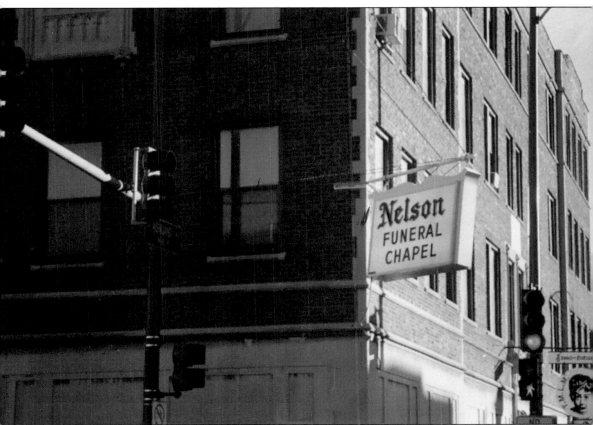

THE NELSON FUNERAL CHAPEL, 5149 N. ASHLAND AVENUE. Family owned and operated for more than half a century, the Nelson Funeral Chapel remains a pioneer in the Andersonville community. Mrs. Vera Nelson, the current owner and president, has run the business since the passing of her husband John (opposite top) in 1967. Mrs. Nelson grew up in the area and continues to serve the community in many volunteer capacities, most notably through Ebenezer Lutheran Church where she has been a confirmed member since 1934. (Photographs by Paul Michael Peterson; courtesy of Mrs. Vera Nelson.)

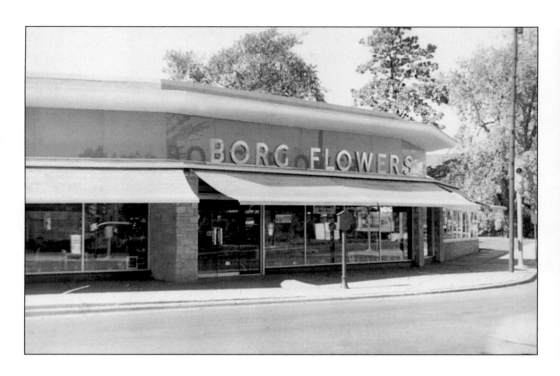

BORG FLOWERS AND GIFTS. A Swedish staple since 1932, Borg Flowers and Gifts was noted not only for flowers, but also for gifts and furniture. Karl "Olle" Erickson, a Swedish immigrant, and husband to Susan Erickson—owner of The Sweden Shop in Chicago—spent many years working and later running the popular north side shop. After taking the store over from Marius Borg and his wife, Erickson used his carpentry skills to enlarge the store from 550 square feet to more than 22,000.

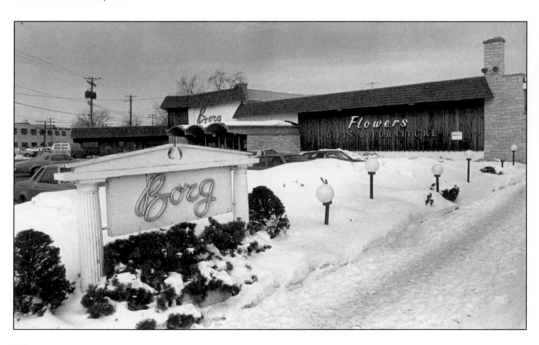

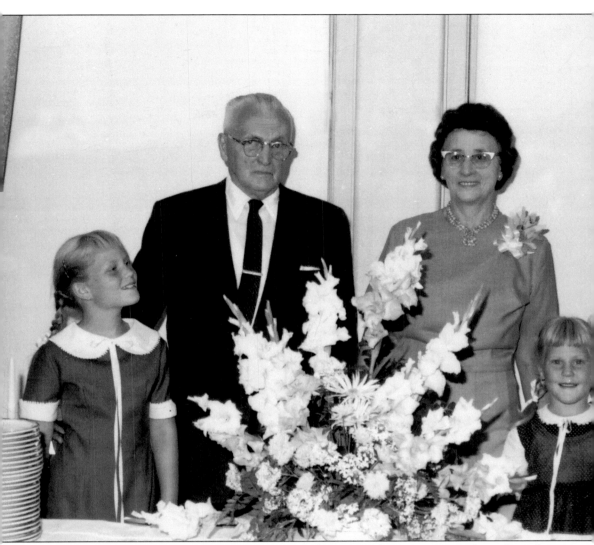

GUSTAF CARLFELDT RETIREMENT, 1966. In today's age where many people seek early retirement, Gustaf Carlfeldt might be seen as an anomaly. After a 40 year career as a physical therapist at Wesley Memorial (now Northwestern Memorial), Gustaf retired at the age of 72. In his farewell tea from Wesley Memorial shown in this photo, Gustaf is joined by wife Ruth and granddaughters Gail and Jane Johnson. (Courtesy of Elizabeth Johnson.)

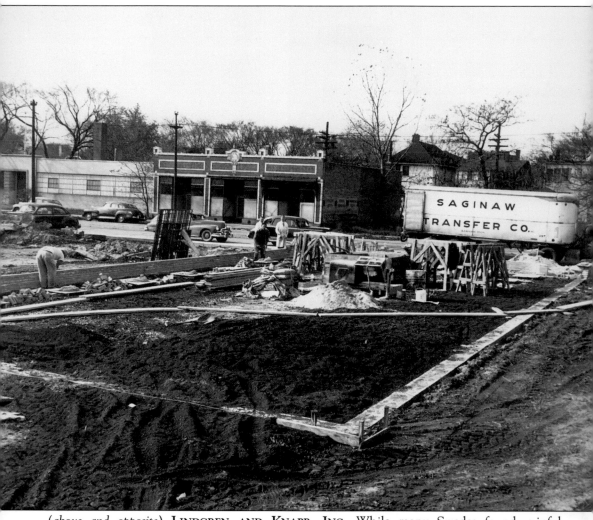

(*above and opposite*) **LINDGREN AND KNAPP, INC.** While many Swedes found gainful employment as laborers, others blazed new trails in business and industry. In 1937, Lindgren and Knapp, Inc. became a premier supplier of cookie and cutter dies to most of the major U.S.

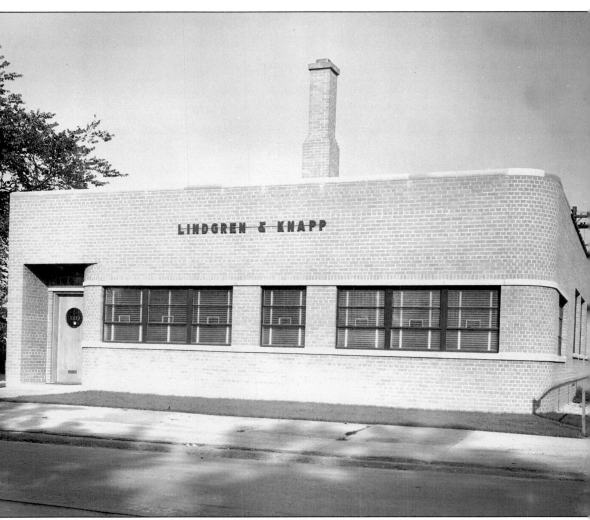

and foreign bakeries. Located in the 5300 block of N. Kedzie Avenue (near Foster Avenue) on Chicago's north side, Lindgren and Knapp remained in business for over 60 years. (Photograph by BAK Studios; courtesy of John Lindgren.)

LINDGREN AND KNAPP, INC. This straightforward advertisement from a bygone era reflects a simplicity in marketing that seems absent from the commercial landscape of businesses today. (Courtesy of John Lindgren.)

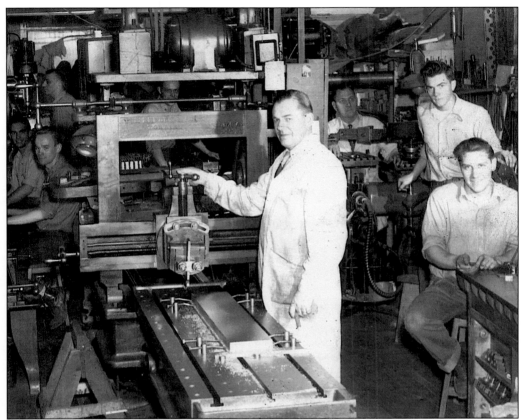

CARL G. LINDGREN SR. (1898–1979). Born in Shelleftea, Sweden, Carl immigrated to America in 1926. After working in the National Biscuit Machine Shop for many years, he started his own company in 1937 with Norwegian partner, Allan Knapp. Here, Carl proudly stands by one of the machines that contributed to Lindgren and Knapp's success for over half a century. (Courtesy of John Lindgren.)

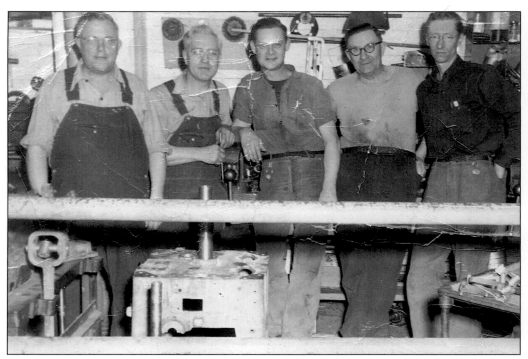

THREE GENERATIONS OF SWEDES—CHARLES PETERSON WITH FELLOW EMPLOYEES, CONTINENTAL CAN COMPANY. The author's grandfather (first from left) poses with fellow employees of the Continental Can Company. A skilled machinist, Charles maintained machinery for the south side company for many years. (Courtesy of Paul Michael Peterson.)

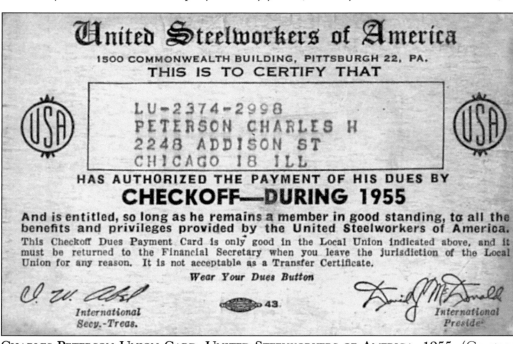

CHARLES PETERSON UNION CARD, UNITED STEELWORKERS OF AMERICA, 1955. (Courtesy of Paul Michael Peterson.)

THREE GENERATIONS OF SWEDES—BRUCE PETERSON, C. 1962. Many of my father's 37 years with Illinois Bell (later Ameritech) were spent as a telephone installer. Here, he pauses for a sample photo from the owner of PK Camera on Irving Park Road in Chicago. Reportedly, the owner was successful in selling a camera to my father. (Courtesy of Paul Michael Peterson.)

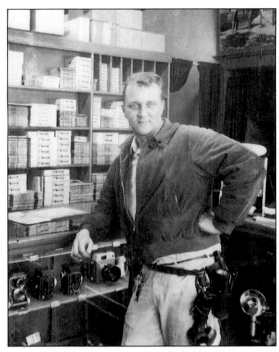

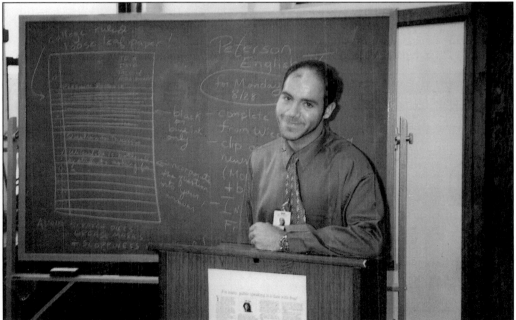

THREE GENERATIONS OF SWEDES—PAUL MICHAEL PETERSON, C. 1999. Although I was not gifted with my grandfather's or father's mechanical expertise, I attended Lane Technical High School on the city's north side less than two blocks from where my grandparents settled after arriving in the U.S. Despite Thomas Wolfe's belief that "you can't go home again," I returned to Lane Tech for a six year period as a faculty member in the Department of English. This photo, taken during the first week of school, reflects the cautious enthusiasm with which many teachers are blessed after returning from a blissful summer respite.

"THE SECRET OF SUCCESS IS CONSTANCY OF PURPOSE"
—BENJAMIN DISRAELI

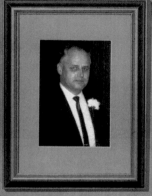
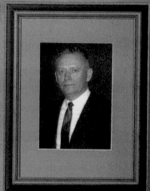

Pehr Bolling *Karl Overland*

In 1956 Karl Overland and Pehr Bolling, founders of Overland Bolling Company, had a vision of a company fueled by people with integrity and strong work habits. This belief in people is the foundation that exists today in Overland Bolling Company, one of the world's highly respected precision metal stamping companies.

Times change but values remain constant and timeless when assessing the caliber of success in the business world. Kenneth Overland and Thomas Bolling understand these concepts and embrace these traditional values as Overland Bolling Company journeys into it's future driven by ideas and technology.

The Company has invested heavily in new technologies for equipment, quality assurance, and training. The company is dedicated to responding to customer needs by increasing productivity and providing superior products and services on a consistent, reliable basis.

Overland Bolling Company intends to remain a leading specialty supplier of precision, quality metal stampings and develops annual, long term business plans to guide its efforts in providing superior products and services to guarantee customer satisfaction.

The unshakable belief in people, and the resulting value of their ideas, as envisioned by Karl Overland and Pehr Bolling is today's strength and tomorrow's catalyst for growth at Overland Bolling Company. There are certain beliefs, proven over time, that simply should not change.

OVERLAND BOLLING COMPANY ADVERTISEMENT. Headquartered in Franklin Park, Illinois, Overland Bolling established itself as a well known and highly respected precision metal stamping company. (Courtesy of Pehr Bolling.)

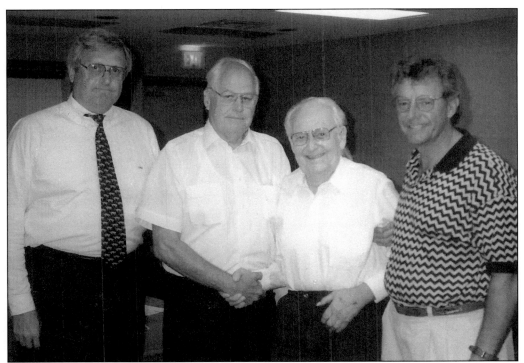

TWO GENERATIONS OF EXCELLENCE. Pictured from left are Tom Bolling, Pehr Bolling, Karl Overland, and Ken Overland. After founding partners Pehr Bolling and Karl Overland stepped down, sons Tom Bolling and Ken Overland continued to represent the high caliber of success for which Overland Bolling was known. (Courtesy of Pehr Bolling.)

OVERLAND BOLLING COMPANY ADVERTISEMENT. (Courtesy of Pehr Bolling.)

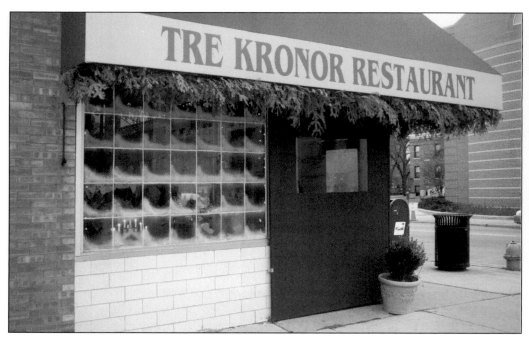

TRE KRONOR RESTAURANT, 3258 W. FOSTER AVENUE. Owners Larry Anderson and wife Patty Rasmussen operate what some patrons consider to be the city's best Scandinavian cooking. Conveniently situated across the street from North Park University in Albany Park on the city's north side, the restaurant offers an eclectic menu of Swedish delicacies for those seeking breakfast, lunch, or dinner. In the early years, when Larry and Patty first took on the venture, 20 hour days were not uncommon. Often, the holiday season commands a similar commitment. The investment has paid off, however: Mayor Daley and Chicago writer Studs Terkel are among the loyal regulars. (Photographs by Paul Michael Peterson.)

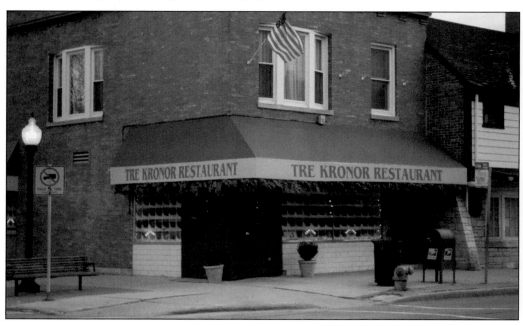

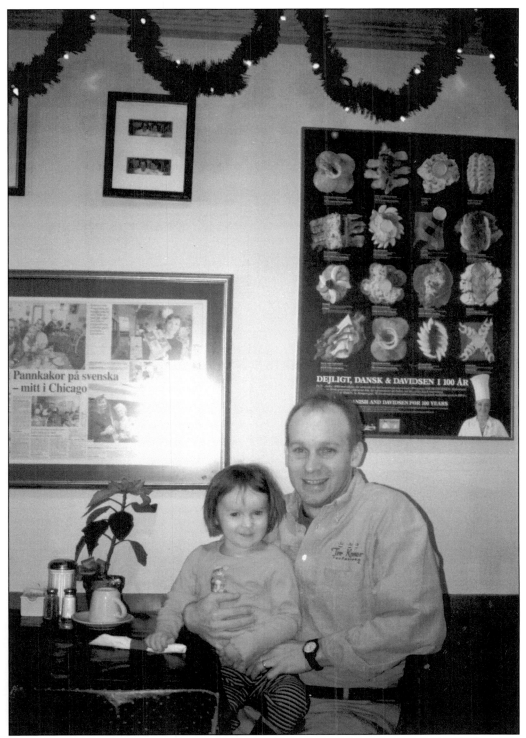

TRE KRONOR OWNER LARRY ANDERSON WITH DAUGHTER MAGDALENA, C. 2003. In a rare moment of rest, Larry Anderson enjoys some time with daughter Magdalena immediately after the breakfast rush. (Photograph by Paul Michael Peterson.)

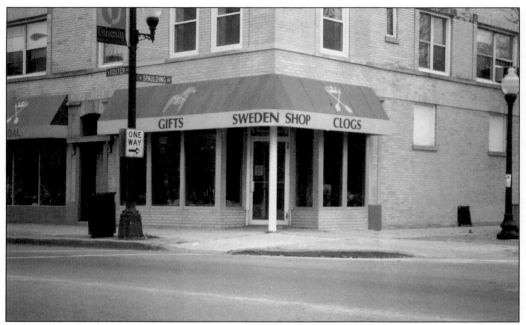

THE SWEDEN SHOP. Only steps from the highly popular Tre Kronor Restaurant, The Sweden Shop remains a Swedish landmark in Chicago. As they celebrate their 55th anniversary, The Sweden Shop is the only Swedish gift shop in the city that ships to Hawaii and Alaska. (Photograph by Paul Michael Peterson.)

SUSAN ERICKSON. The daughter of Alf and Ebba Thufvesson, Susan Erickson has operated The Sweden Shop since April 1, 1989. Her friendly manner and helpful spirit have contributed to the shop's increasing success in recent years. (Photograph by Paul Michael Peterson.)

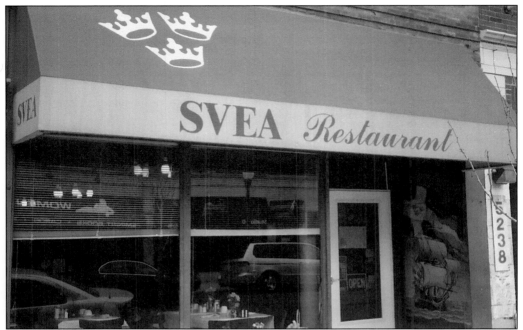

SVEA RESTAURANT, 5236 N. CLARK STREET. Known as "home of the Viking breakfast," current owner Tom Martin continues the Swedish culinary tradition started by Andersonville pioneer Kurt Matthiasson. Open seven days a week, the Scandinavian eatery is well known for their Swedish pancakes and lingonberries. (Photograph by Paul Michael Peterson.)

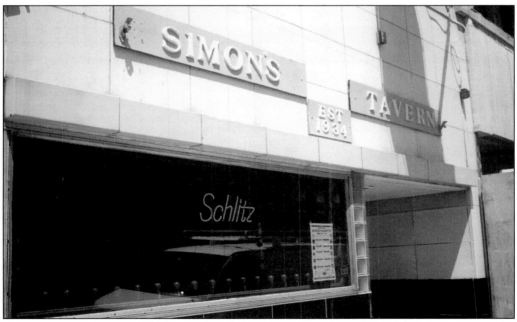

SIMON'S TAVERN, 5210 N. CLARK STREET. Scott Martin, son of Tom Martin, continues the tradition started by Simon Lundberg in 1934. Long considered the "anchor of Andersonville," Simon's Tavern offers its patrons the same friendly and relaxed atmosphere for which it was known in the days after Prohibition. (Photograph by Paul Michael Peterson.)

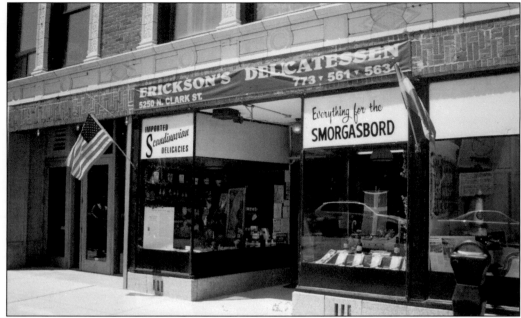

ERICKSON'S DELICATESSEN AND FISH MARKET, 5250 N. CLARK STREET. Erickson's Deli, a longtime neighborhood staple, continues to serve the masses—both year round and during the Christmas season. Established in 1925, Erickson's is open seven days per week and ships delicacies nationwide. Visitors desiring to avoid the crowds during the Christmas season would do well to take a number, exit for an hour of merriment at Simon's Tavern, then return just in time to place an order. (Photograph by Paul Michael Peterson.)

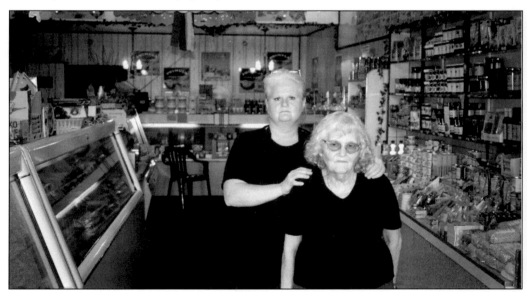

ANN-BRITT NILSSON AND ANN-MARI NILSSON. Having immigrated to America from Sweden in 1958, the mother and daughter team have owned and operated Erickson's Delicatessen and Fish Market since 1978. Shoppers, who will immediately notice the store's warm and vintage feel, may be hard-pressed to leave empty-handed considering the tremendous selection. (Photograph by Paul Michael Peterson.)

"EVERYTHING FOR THE SMORGASBORD." Whether your craving is for tasty Pepparkakor cookies pictured above or the rows of delicacies shown below, Erickson's caters to the most discriminating of palates. (Photographs by Paul Michael Peterson.)

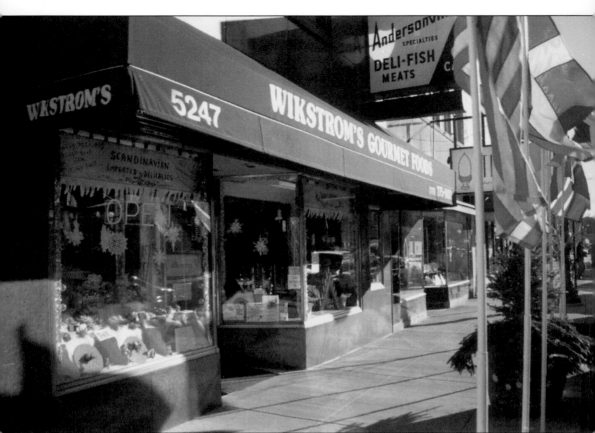

WIKSTROM'S GOURMET FOODS, 5247 N. CLARK STREET. Directly across the street from Erickson's Delicatessen stands Wikstrom's Gourmet Foods. Owner Ingvar Wikstrom grew up on a farm in Sweden, learning how to cook from his mother as well as how to prepare foods from scratch. While visiting the U.S. as an exchange student at Augustana in Rock Island, Illinois, Ingvar developed an interest in the catering business. After traveling between Sweden and the United States, Ingvar married in 1959 and returned to the U.S. to achieve the American dream. Over four decades later, Wikstrom's Gourmet Foods continues its success as an institution in the Scandinavian community. (Photograph by Paul Michael Peterson.)

Four

TRADITION AND COMMUNITY

The December scene was always the same. After struggling to locate parking in a small cubbyhole on Ashland Avenue, my father, brother, and I trekked through the melting sleet that laid claim to the sidewalks and curbs of Andersonville. Our simple quest proved more formidable each year as we challenged fellow Swedish gladiators lurching for numbers and awaiting their turns in the delicatessens in search of precious ingredients for Christmas Eve smorgasbord. A visit to Simon's Tavern was always imminent after grasping #109 while the deli clerk shouted for #34. At Simon's, we could reminisce about the old year and toast to the new, while avoiding the throngs of shoppers who wrestled for supremacy as they made their way to the glass cases of the deli counter in search of culinary delights.

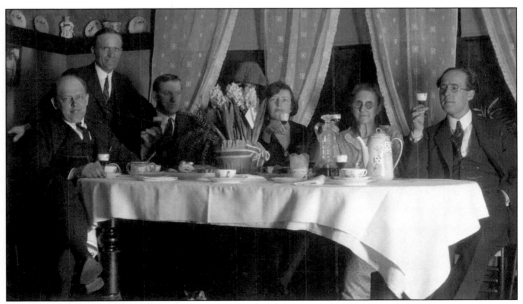

SWEDES SHARE A TOAST. Much as in the present age, many find a sense of close community when gathered at the dining table. (Courtesy of Elsie Lindgren.)

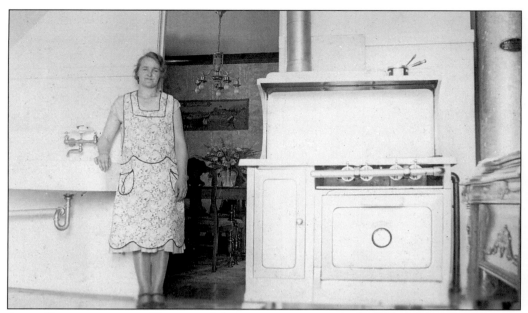

ANNA PETERSON IN THE KITCHEN. Like many immigrant women of her day, Anna Peterson found time to maintain a household, raise children, and hold work in a bakery. She took great pride in preparing many Swedish dishes for her family. Notice the utilitarian nature of the kitchen contrasted with the elaborate setting of the dining room in the background. (Courtesy of Bruce Peterson.)

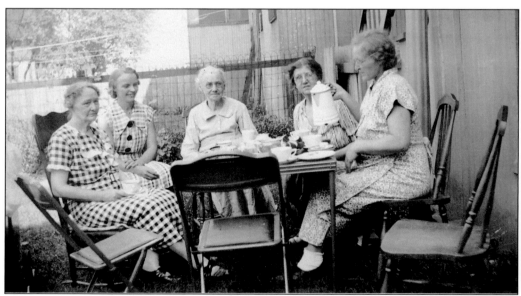

SWEDISH COFFEE IN THE BACKYARD, AUGUST, 1937. In pure storybook fashion, these Swedish women are sharing a pot of coffee and coffeecake in the backyard as summer wraps to a close in 1937. Time spent together in this fashion perpetuated many sincere and lasting friendships that defined the spirit of the age. (Courtesy of Bruce Peterson.)

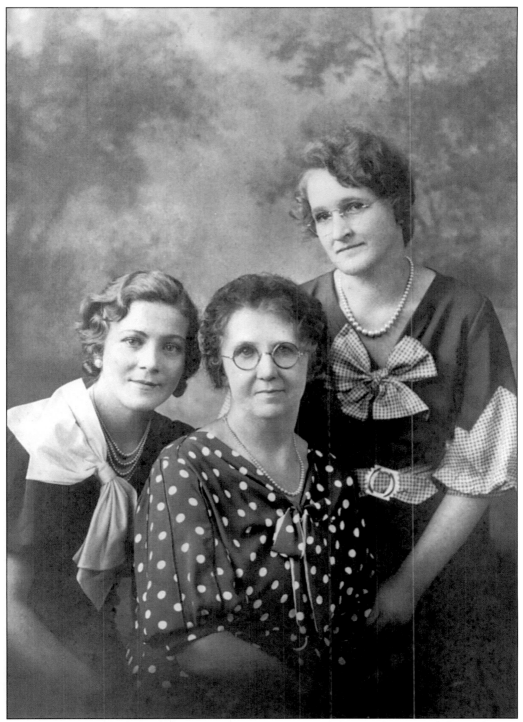

THREE SWEDISH WOMEN IN PORTRAIT. Pictured, from left to right, are Edith Anderson, Hildur Rex, and Anna Peterson. Edith Anderson worked as a domestic for the McCormick family (brother to the owner of the *Chicago Tribune*), while Hildur Rix and Anna Peterson worked in a number of bakeries in Chicago. (Courtesy of Evelyn Reese.)

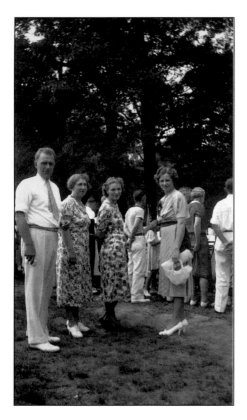

SWEDISH PICNICS. The four photos on these two pages reflect a common and highly popular activity that brought many Swedes together to create a sense of community. From the look of these gatherings, picnics were gala affairs that required relatively formal apparel and the family's best china. (Courtesy of Annette Peterson.)

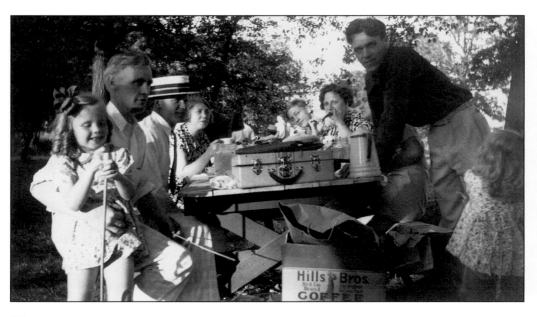

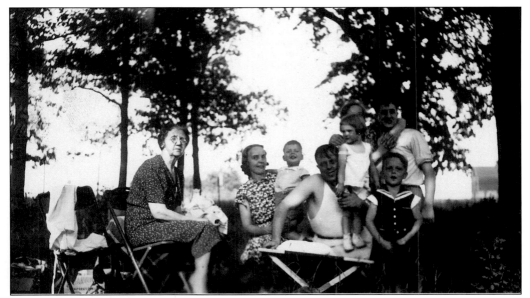

(Courtesy of Bruce Peterson.)

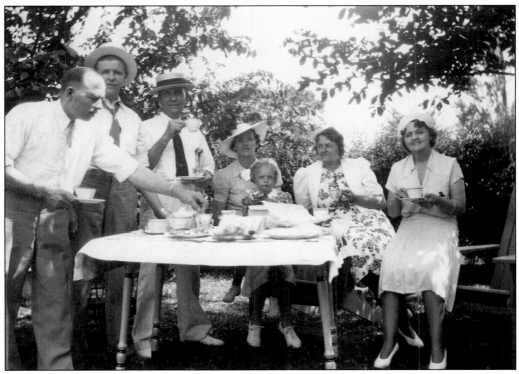

(Courtesy of Elsie Lindgren.)

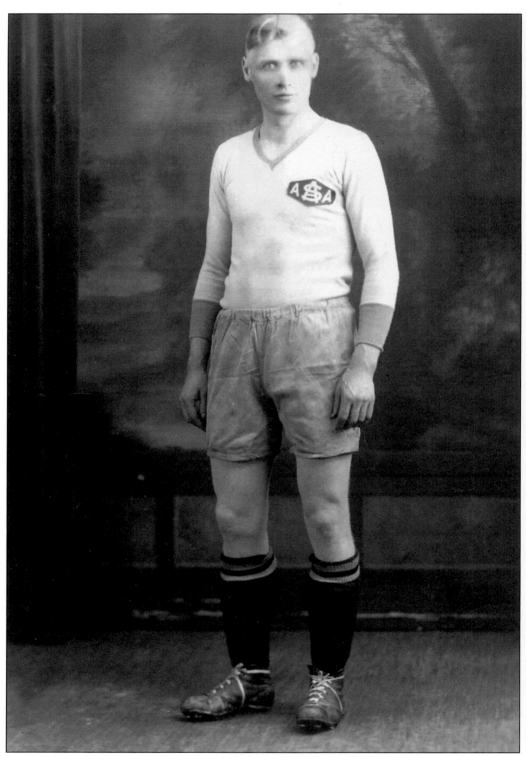

RUDY EHRLIN. Striking a trim and athletic silhouette, Rudy Ehrlin poses in full soccer dress. (Courtesy of Annette Peterson.)

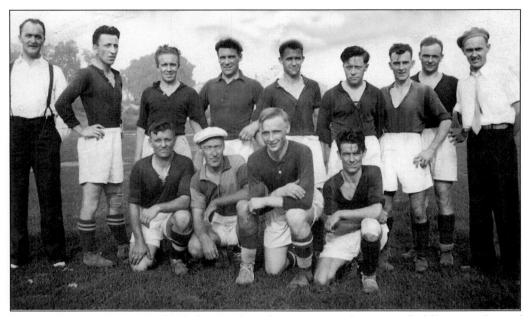

VIKING SOCCER TEAM. Rudy Ehrlin (smiling, first row center) poses with fellow members of the Viking Soccer Team. Athletic participation provided many with a physical release from the stresses of everyday life, while cultivating a highly appreciated sense of camaraderie as evidenced by the youthful optimism expressed here. (Courtesy of Annette Peterson.)

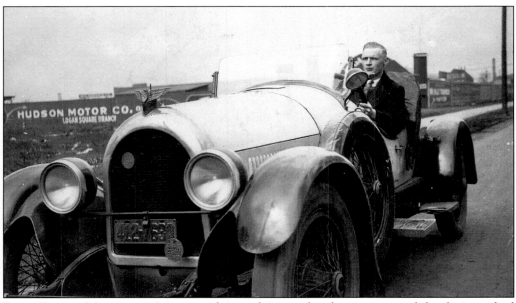

RUDY EHRLIN MOTORING. In an era when sophisticated and sporty automobiles distinguished one from his peers, the Swedish immigrant could derive a sense of pleasure out of the individuality afforded by a motor vehicle. Here, Rudy Ehrlin enjoys a day of motoring near the Logan Square branch of the Hudson Motor Company. Note the detailed craftsmanship on the streamlined hood ornament. (Courtesy of Annette Peterson.)

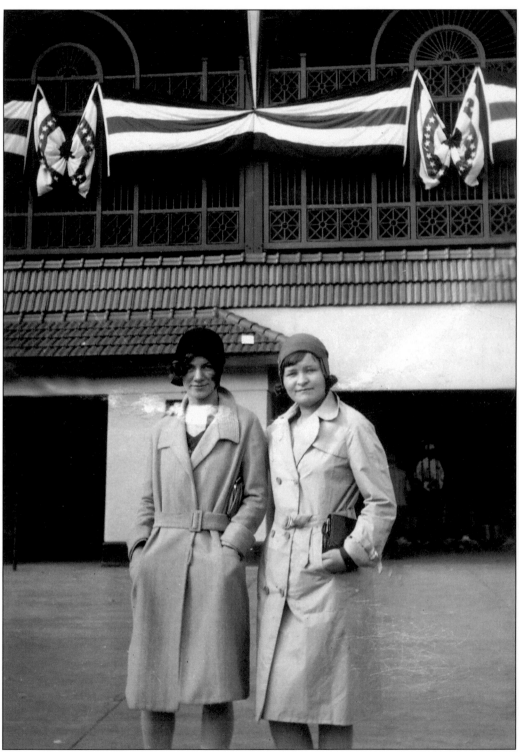

EDITH EHRLIN WITH FRIEND. Here, Edith Ehrlin (left) shows her true sports colors as she poses with a friend outside Wrigley Field. (Courtesy of Annette Peterson.)

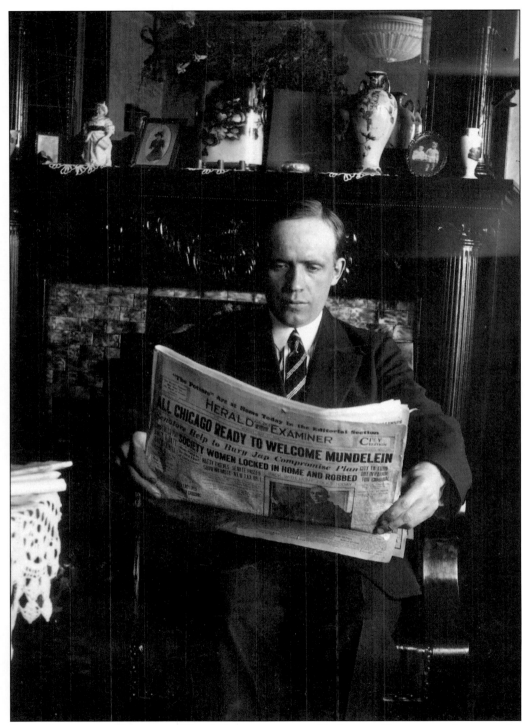

ERNIE LINDQUIST RELAXING. The daily newspaper could also provide a sense of community for many Swedish immigrants wishing to perfect their English skills, while catching up on the news of the day. Here, Ernie Lindquist reads an issue of the *Chicago Herald Examiner*, a popular city newspaper from 1918 to 1939. (Courtesy of Elsie Lindgren.)

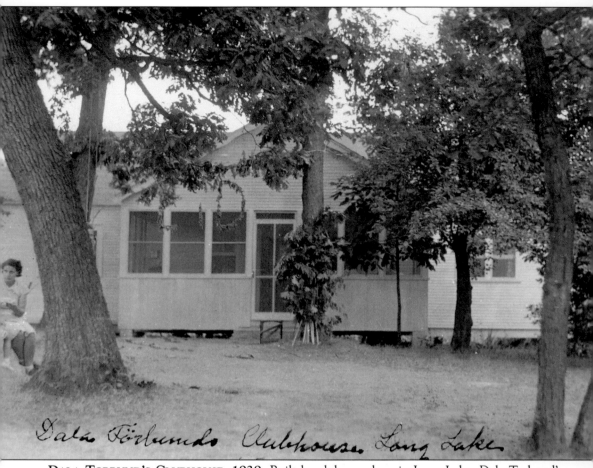

Dala Förbunds Clubhouse Long Lake

DALA TORBUND'S CLUBHOUSE, 1939. Built by club members in Long Lake, Dala Torbund's Clubhouse served as a weekend retreat for its members. Swedes looking to establish a sense of community sought to replicate the rural nature of Sweden by escaping to a weekend retreat in a rural, country atmosphere. (Courtesy of June Anderson.)

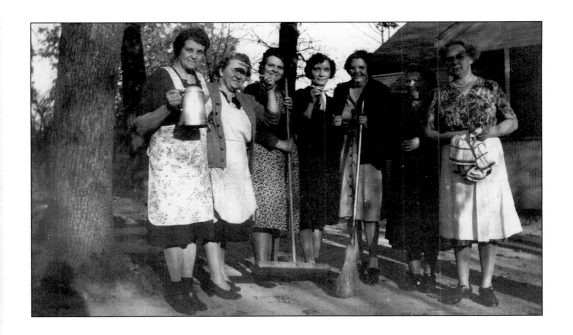

LONG LAKE, 1944. Anna Anderson (at left holding coffeepot) with friends at Long Lake. The ladies cooked and cleaned (*above*) while the men provided the music (*below*). Saturday evenings at Dala Torbund's consisted of great parties and dances. (Courtesy of June Anderson.)

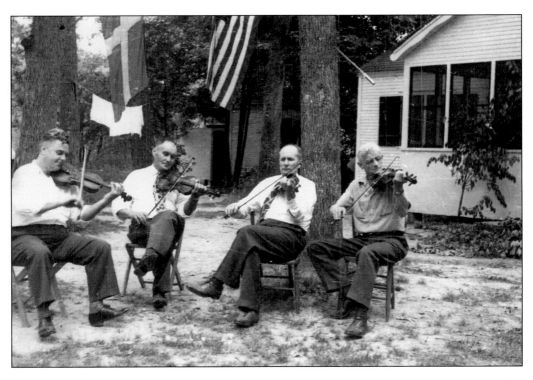

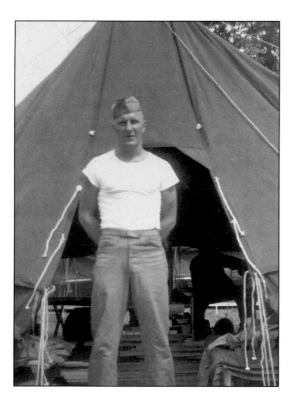

RALPH JOHNSON IN THE SOUTH PACIFIC, 1944. Lindor Johnson's son Ralph served his country as a member of the armed forces in the South Pacific. Many Swedish immigrants and children of immigrants honored tradition and community by serving in the military. (Courtesy of Ralph Johnson.)

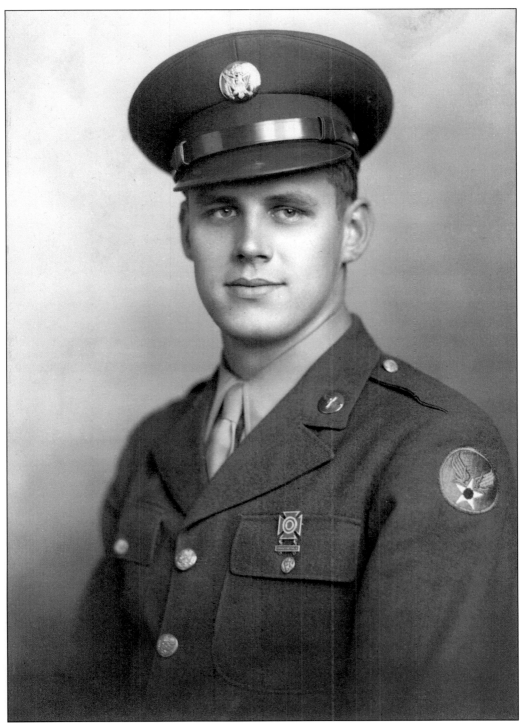

PEHR BOLLING, 1945. After enlisting in the Army in 1943, Pehr Bolling was called to active duty in January, 1944 and sent to the island of Tinian. As a member of the 6th Bomb Group of the 24th Bomb Squadron, his job entailed making enlargements of maps used for the briefing of pilots. In January of 1946, he was honorably discharged. (Courtesy of Pehr Bolling.)

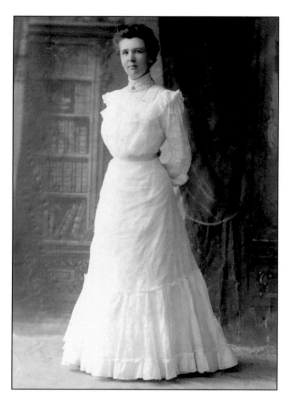

HILDUR RIXON. Hildur is hown as a young woman (*left*), shortly after the turn of the century, and in her late 70s in 1956 (*below*). A kind and generous woman, Hildur never married after immigrating to America from Sweden. (Courtesy of Evelyn Reese and Bruce Peterson.)

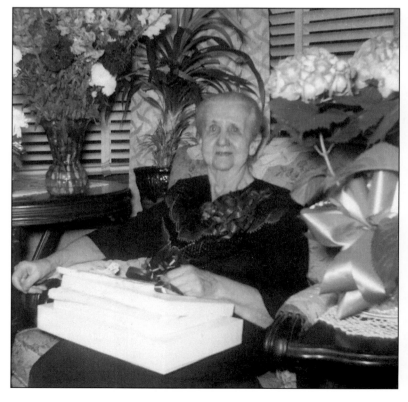

THE UNITED STATES OF AMERICA

No. 2502711

CERTIFICATE OF NATURALIZATION

Petition, Volume 222 *Number* 30930.

Description of holder: Age, 52 *years; height,* 5 *feet,* 8 *inches; color,* White *complexion,* light *; color of eyes,* blue *; color of hair,* brown *; visible distinguishing marks,* none

Name, age and place of residence of wife

(NOTE:—AFTER SEPTEMBER 22, 1922, HUSBAND'S NATURALIZATION DOES NOT MAKE WIFE A CITIZEN.)

Names, ages and places of residence of minor children

ORIGINAL

UNITED STATES OF AMERICA
NORTHERN DISTRICT OF ILLINOIS } ss:

Hilda Maria Rex
(Signature of Holder)

Be it remembered, that HILDA MARIA REX
then residing at number 3232 Sheffield Ave., *Street,*
City/Town of Chicago, *State/District of* Illinois *who previous*
to her naturalization was a citizen subject of Sweden *having applied to be admitted a citizen*
of the United States of America pursuant to law, and at a Regular *form of the* District
court of the United States *held at* Chicago *on the* 8th *day of* June
in the year of our Lord nineteen hundred and 27 *the court having found that the petitioner*
intends to reside permanently in the United States, and that he *had in all respects*
complied with the Naturalization Laws of the United States, and that he was entitled
to be so admitted, it was thereupon ordered by the said court that he be admitted as a
citizen of the United States of America.

[SEAL]

In testimony whereof the seal of said court is hereunto affixed on the 8th *day of*
June *in the year of our Lord nineteen hundred and* 27 *, and of our*
Independence the one hundred and fifty-first.

Charles M. Bates
Clerk, District Court of the United States,
Northern District of Illinois.
(Official character of attestor)

DEPARTMENT OF LABOR

CERTIFICATE OF NATURALIZATION, 1927. Hilda Maria Rex, who later changed her name to Hildur Rixon, earned her American citizenship on June 8, 1927.

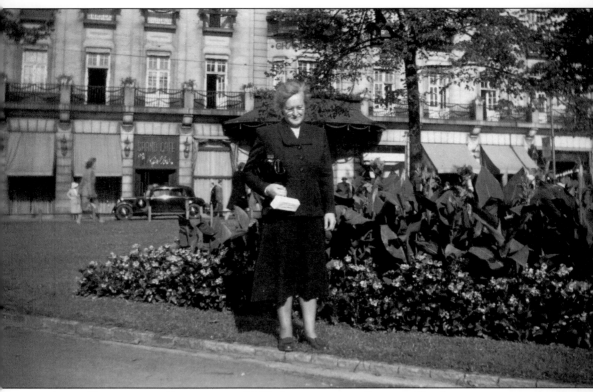

ANNA PETERSON IN STOCKHOLM, 1948. It was common for many Swedes to return home and visit family. Typically, the trips lasted for several months rather than the one-week vacations for which Americans are known today. In this photo, Anna Peterson stands on a curb in Stockholm holding what looks like a box of pastry from the Grand Café in the background. (Courtesy of Bruce Peterson.)

Form I-131
(Old 631)
U. S. DEPARTMENT OF JUSTICE
IMMIGRATION AND NATURALIZATION SERVICE
(Edition January 1941)

APPLICATION FOR REENTRY PERMIT

No.

Reviewer ..

To the HONORABLE COMMISSIONER OF IMMIGRATION AND NATURALIZATION:

The undersigned, being an alien, hereby makes application for a reentry permit, as provided for in Section 10 of the Immigration Act of 1924, and submits the following data in support thereof:

The name I now use is (Print full name) ANNA ELEONORA PETERSON
........................(First)................................(Middle)................................(Last)

LAST arrived in the United States {
Name of steamship KUNGSHOLM 3RD
..(First, second, or third class)
Port of arrival NEW YORK, N.Y.
Date of arrival OCT. 19, 1931

(Excluding reentries before July 1, 1940, after absence of less than 6 months in Canada and Mexico.)

Name under which admitted ANNA ELEONORA OLSON

Father's name NELS OLSON Mother's maiden name LINA GILLBERG

At time of entry my age was 23 - 3 ; I was {Single} SINGLE My occupation was MAID
..{Married}

Place of birth VARMLAND, SWEDEN Date 8 - 11 - 1903

Last permanent residence before date of entry SWEDEN ARVIKA
..(Country)..(City or town)

Name and complete address of nearest relative or friend at time of entry in country whence came HANNA PERSON ✓

3232 SHEFFIELD AVE, CHICAGO, ILLINOIS

Name and address of person to whom destined at time of last entry CHARLES H. PETERSON

846 ALDINE AVE, CHICAGO, ILLINOIS

By whom accompanied at time of last entry NONE

I am a citizen of SWEDEN by BIRTH
..(Country)..(Birth or naturalization)

I am traveling on a passport issued by SWEDISH CONSUL CHICAGO, ILL.
..(Name of country)

On FEB. 19, 1948 valid until FEB 19 1953
........(Date)..(Date)

Personal description as of date of application:

Age 44 Height 5 ft. ft. 3 inches Weight 160 lbs.

Complexion LIGHT Color of hair BLOND Color of eyes BLUE

Marks of identification NONE

Applicant's present residence in the United States:

(Street and number) 2248 W. ADDISON ST. CHICAGO, ILLINOIS

(City or town) CHICAGO (State) ILLINOIS

Resided at the above address TEN years EIGHT months.

My temporary address abroad will be GILSERUD, ARVIKA SWEDEN

{Single}
{Married} Name and address of nearest relative (give name of husband or wife if married) CHARLES H. PETERSON

2248 W. ADDISON ST. CHICAGO, ILLINOIS ✓

My business or employment is MACHINIST

Place of business or employment 5401 W. 65 TH. ST. CHICAGO, ILLINOIS

Name of employer CONTINENTAL CAN ING.

Port and date of proposed departure from the United States NEW YORK MAY 21, 1948
..(Port)..(Date)

Name of vessel on which sailing GRIPSHOLM Length of proposed absence 6 MOS.

Countries to be visited SWEDEN + NORWAY

Reasons for going abroad VISIT MOTHER IN ARVIKA, VARMLAND
..(Explain in detail)
SWEDEN
..
..

If you are the holder of a certificate of registry or of lawful entry, give number of the certificate

My last application for reentry permit was filed 1931 Application number

(Sheet 1)

16—16182-1

U 28807

APPLICATION FOR REENTRY PERMIT, 1948. Despite living in America for an extended period of time, reentry into the U.S. after visiting relatives abroad was not as simple as passing through a gate. This Application for Reentry Permit, completed by the author's grandmother after a six month visit to Sweden, details the necessary bureaucracy maintained by the U.S. Department of Justice at the time. (Courtesy of Paul Michael Peterson.)

CHARLES H. PETERSON, C. 1950. I've long admired this black and white photograph of my grandfather enjoying a shot and a beer in the yard of some friends from the country. As my brother once remarked upon seeing the photo, "He's not getting up anytime soon, is he?" Having never had the pleasure of meeting him, I often look for the photo to communicate a thousand words. (Courtesy of Paul Michael Peterson.)

THE UNITED STATES OF AMERICA

ORIGINAL
TO BE GIVEN TO
THE PERSON NATURALIZED

CERTIFICATE OF **NATURALIZATION**

No. 6319609

Petition No. 330237

Personal description of holder as of date of naturalization: Age 51 *years; sex* male *; color* white *; complexion* fair *; color of eyes* blue *; color of hair* brown *; height* 5 *feet* 8 *inches; weight* 200 *pounds; visible distinctive marks* none

Marital status married *former nationality* Swedish

I certify that the description above given is true, and that the photograph affixed hereto is a likeness of me.

Carl Helgard Emanuel Peterson
(Complete and true signature of holder)

UNITED STATES OF AMERICA }
NORTHERN DISTRICT OF ILLINOIS } *ss:*

Be it known, that at a term of the ———— *District* ———— *Court of*
———— *The United States* ————
held pursuant to law at ———— *Chicago* ————
on August 3, 1948 *the Court having found that*
CARL HELGARD EMANUEL PETERSON

then residing at 2248 West Addison Street, Chicago, Illinois, *. intends to reside permanently in the United States (when so required by the Naturalization Laws of the United States), had in all other respects complied with the applicable provisions of such naturalization laws, and was entitled to be admitted to citizenship, thereupon ordered that such person be and (s)he was admitted as a citizen of the United States of America.*

In testimony whereof the seal of the court is hereunto affixed this 3rd *day of* August *in the year of our Lord nineteen hundred and* forty-eight *, and of our Independence the one hundred and* seventy-third.

Roy H Johnson
Clerk of the ———— U.S. District ———— *Court.*
By *Edna H Torkenson* ———— *Deputy Clerk.*

It is a violation of the U.S. Code, and punishable as such, to copy, print, photograph, or otherwise illegally use this certificate.

Seal

Carl Helgard Emanuel Peterson

DEPARTMENT OF JUSTICE

CERTIFICATE OF NATURALIZATION, 1948. One striking characteristic of this certificate at which I marvel is the beautiful penmanship of my grandfather's signature. Despite the blue collar nature of his work, handwriting was a reflection of pride in the family name. In our modern age, when civic-minded identity is frequently ignored and taken for granted, it may be interesting to note the presence of the phrase, *"former nationality"* on the fourth line of the certificate. (Courtesy of Paul Michael Peterson.)

81

"It's Glogg Time!" No three words could make a proud Swede happier. Glogg, a popular Christmas drink among Swedes, requires port wine, brandy, vodka, slivered almonds, cardamom pods, raisins, and a few other secret ingredients which vary from family to family. The author suggests always serving glogg warm. This photo reflects the window of Simon's Tavern during the festive Christmas season. (Photograph by Paul Michael Peterson.)

EVELYN REESE CELEBRATES LUCIA, CHRISTMAS, 1956. In Sweden, Lucia Day is celebrated on the 13th day of December. The modern Lucia procession appeared in the 19th century when a "Lucia bride" wearing a lighted crown and followed by a train of "bridesmaids" and "star-boys" arrived early in the morning while it's still dark. Those whom she visits are met with coffee, saffron rolls and gingerbread. Here, Evelyn Reese carries out the Lucia tradition in December of 1956. (Courtesy of Evelyn Reese.)

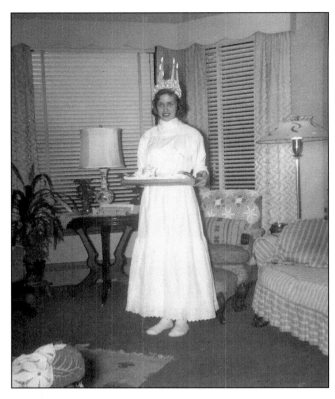

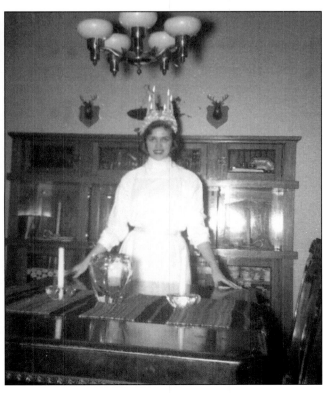

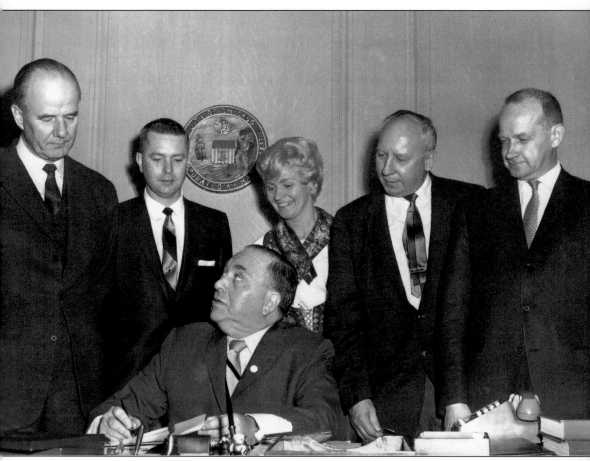

SWEDISH FLAG DAY PROCLAMATION, MAY 19, 1966. Although born an Irishman, Chicago Mayor Richard J. Daley certainly made himself an honorary Swede when he signed a proclamation declaring May 19 as Swedish Flag Day. Pictured from left behind the Mayor is Bo Jarnstedt (council general of Sweden), Olle Erickson (vice-chairman, Central Swedish Committee of Chicago), Ingrid Bergstrom, Clarence Leaf (vice-chairman, Central Swedish Committee of Chicago), and Eric G. Erricsson (executive secretary, Central Swedish Committee of Chicago). (Photograph by Mart Studios; courtesy of Swedish American Archives of Greater Chicago, located at North Park University, Chicago, Illinois.)

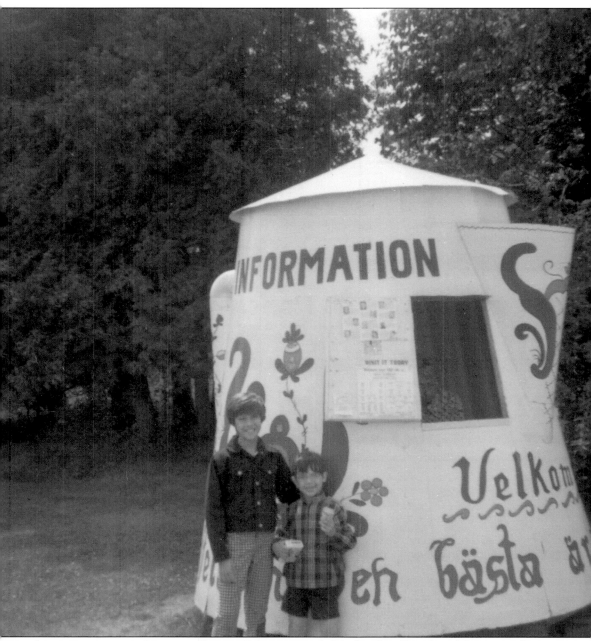

INDUSTRIAL-SIZED SWEDISH COFFEE POT, C. 1975. My brother David and I pose in front of a rather large Swedish coffee pot while on vacation in Door County, Wisconsin in 1975. That's me on the right with the plaid jacket and the rather stylish glasses. (Courtesy of Paul Michael Peterson.)

2003 MIDSOMMARFEST ADVERTISEMENT. In 2003, Andersonville celebrated the 38th annual "Midsommarfest" on June 14th and 15th. Midsommarfest, a highly popular Swedish summer festival, celebrates with food, arts and crafts, Swedish dancing, and a dance around the Maypole. (Photograph by Paul Michael Peterson.)

JOHN LINDGREN PREPARES SWEDISH SMORGASBORD. Preparing smorgasbord at Christmas requires a skilled degree of multi-tasking as John Lindgren aptly illustrates here. (Courtesy of John Lindgren.)

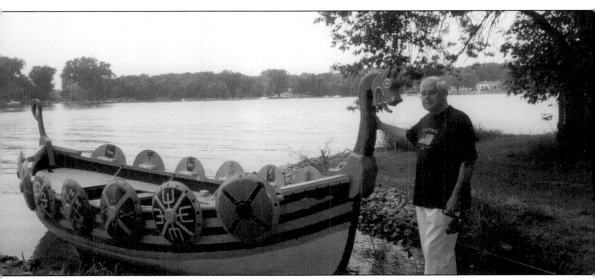

PEHR BOLLING WITH HOMEMADE VIKING SHIP. Made from a spare lifeboat from Great Lakes, this homemade Viking ship includes a hand-carved bow and stern, and handmade Viking shields made from aluminum snow saucers. Note the plaques detailing the various Swedish provinces fastened to the inside of the shields. Mr. Bolling, a successful businessman and skilled artisan, enjoys an occasional boat ride on Lake Marie when surrounded by family. (Courtesy of Pehr Bolling.)

ANDERSONVILLE. Revitalized as a Swedish community in 1964, Andersonville merchants began a tradition of cleaning their store windows and sidewalks at the ringing of a bell each morning at 10 o'clock. The renewed sense of pride served as an investment in the community as well as in one's Swedish heritage. (Photographs by Paul Michael Peterson.)

ANDERSONVILLE WAS CREATED IN 1964 AND INSPIRED THE MERCHANTS TO TAKE A RENEWED PRIDE IN THEIR SHOPS AND THE SURROUNDING COMMUNITY.

AS A RESULT, EVERY MORNING AT 10:00, A MAN WALKED UP AND DOWN THE STREETS -- FROM FOSTER TO BRYN MAWR -- RINGING A BELL AND CARRYING THIS SIGN.

THIS WAS THE SIGNAL FOR THE MERCHANTS TO COME OUT AND CLEAN THEIR STORE WINDOWS AND THE SIDEWALKS.

THIS RITUAL MADE ANDERSONVILLE THE CLEANEST COMMUNITY IN CHICAGO. IT'S REPUTATION SPREAD FAR AND WIDE... EVEN TO THE SHORES OF SCANDANAVIA.

SWEDISH MAYPOLE AT MIDSOMMARFEST, c. 2003. According to information from the Swedish Institute, the afternoon of Midsummer Eve dictates that people gather for traditional games and ring-dancing around the maypole. Afterwards, they enjoy a traditional dinner of fresh potatoes and pickled herring accompanied by beer and schnapps to drink. In the photograph below, participants dance around the maypole to honor the Swedish tradition. (Photographs by Joan Marie Bowers.)

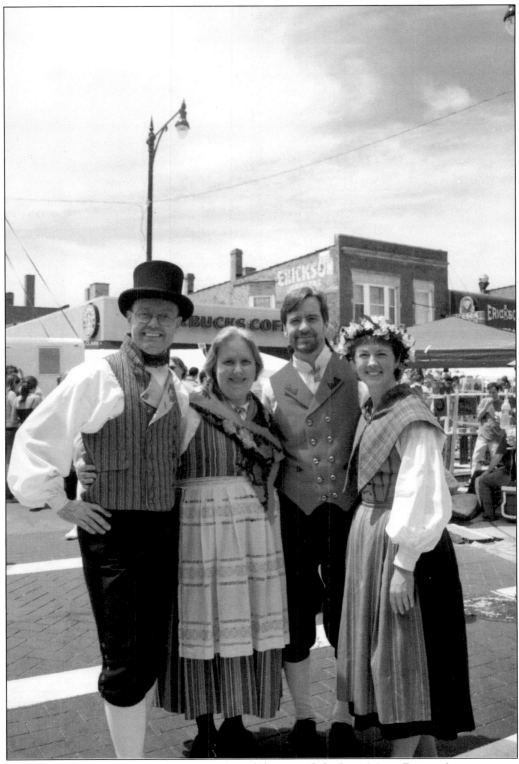

NORDIC DANCERS, MIDSOMMARFEST 2003. (Photograph by Joan Marie Bowers.)

Skando Chicago is a fun group of Scandinavians and Scandinavian Americans who get together on the 2nd and 4th Wednesday of each month for cocktails and conversation. Come join us at 6:30pm for our next Pub Night at our usual hangout in Lincoln Park called The Store (2002 N. Halsted).

Skandinavisk Happy Hour!

Can't make it during the week? Sign up online for our mailing list and keep up to date with our various sponsored events and parties. From our Summer Soccer team to our Annual Julebord and ski trips, we have something going on year round. Until then, vi ses på onsdag!

For more details. visit
www.SkandoChicago.com
or call 312.397.8924

skando chicago
THE SCANDINAVIAN SOCIAL KLUBB

SKANDO CHICAGO. Skando Chicago is a social group comprised of Scandinavians and Scandinavian Americans who congregate on the 2nd and 4th Wednesday of each month. Offering sponsored events such as summer soccer and winter ski trips, the club fosters a sense of community and cultural pride among its members. (Photograph by Paul Michael Peterson.)

Five

NOTABLE SWEDES IN CHICAGO

Known for their stoic and unassuming nature, the Swedes who made good in America—whether immediately after emigrating or after two to three generations in America—kept their pride in check and remained committed to the traditional Scandinavian ethic of producing through hard work. Although the notables who characterize these next few pages varied in generation, economic scope, and overall achievement, the common denominator among all of them is the firm loyalty each of them displayed in remembering their Swedish roots.

HONORARY KURT MATHIASSON STREET. This street sign honoring the late Andersonville pioneer Kurt Mathiasson was placed on part of the street from Foster to Balmoral in 1998. Known as a community leader throughout the Andersonville community, Kurt Mathiasson was well known as the founder of the Swedish American Museum Center and the proprietor of the Svea Restaurant for many years. (Photograph by Paul Michael Peterson; courtesy of Swedish American Museum Center.)

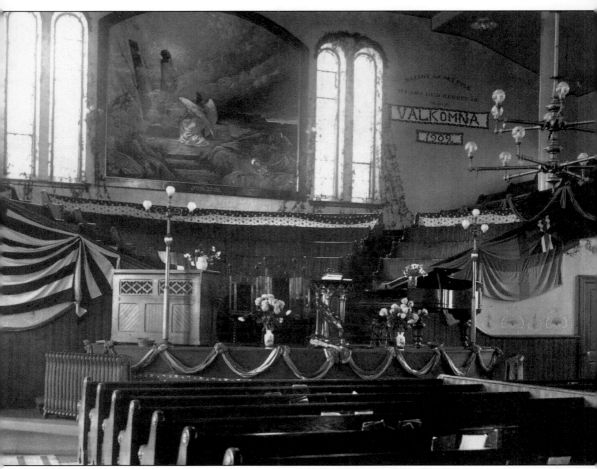

INTERIOR OF SWEDISH MISSION TABERNACLE, CHICAGO, 1902. A mesmerizing photo upon which to gaze, the religious mural above the altar was painted by Justus Bergman, a member of the Swedish Mission Tabernacle which was located at 30th and LaSalle. Though many may not be familiar with Justus, they are most certainly familiar with his daughter, the actress known as Ingrid Bergman. (Courtesy of Covenant Archives and Historical Library, located at North Park University, Chicago, Illinois.)

PORTRAIT OF HENRY BENGSTON, 1912. Henry Bengston (1887–1974), editor of the *Svenska Socialisten* from 1912 until 1920, joined the working-class labor movement and supported many causes of the radical labor movement. (Courtesy of Swedish-American Archives of Greater Chicago, located at North Park University, Chicago, Illinois.)

PEHR SAMUEL PETERSON (1830–1903).
Pehr Samuel Peterson arrived in Chicago in the 1850s. Having received his horticultural training throughout Europe, Peterson established Rose Hill Nursery in 1856 on the north side of the city and became a major supplier for nursery stock throughout the city. Peterson Avenue (shown below) the heavily traversed artery on Chicago's far north side, bears his name to this day. (Pehr Samuel Peterson photograph courtesy of Swedish American Museum Center; photograph below by Paul Michael Peterson.)

ANDREW LANQUIST (1856–1931). (*right*)
After extensive training as a bricklayer
and building mechanic, Andrew Lanquist
emigrated from Sweden in 1881. His
construction firm, Lanquist and Illsley, was
instrumental in creating famous Chicago
landmarks such as Wrigley Field (*below*),
the Wrigley Building on Michigan Avenue,
and the Linnaeus monument (now located
on the University of Chicago campus)
(Lanquist photograph courtesy of Swedish
American Museum Center; photograph
below by Paul Michael Peterson.)

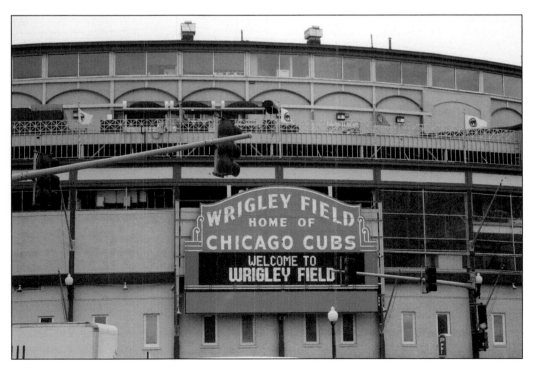

WALGREENS PHARMACY. One of the many Walgreens stores as it appears today. (Photographs by Paul Michael Peterson.)

CHARLES R. WALGREEN SR. (1873-1939). The family of the founder of Walgreen Drug emigrated from Goteborg, Sweden. As a young man in 1893, Walgreen was fired from his drugstore job for neglecting to shovel the sidewalk. Captivated by the city's 1,500 drugstores, he began his success story with one drugstore located at 4134 Cottage Grove Avenue. A generous man and stern employer, Walgreen counted Swedish poet and writer Carl Sandburg among his many friends. Never one to forget his roots, Charles continued to speak and correspond in Swedish throughout his life. (Photograph by Paul Michael Peterson; courtesy of Swedish American Museum Center.)

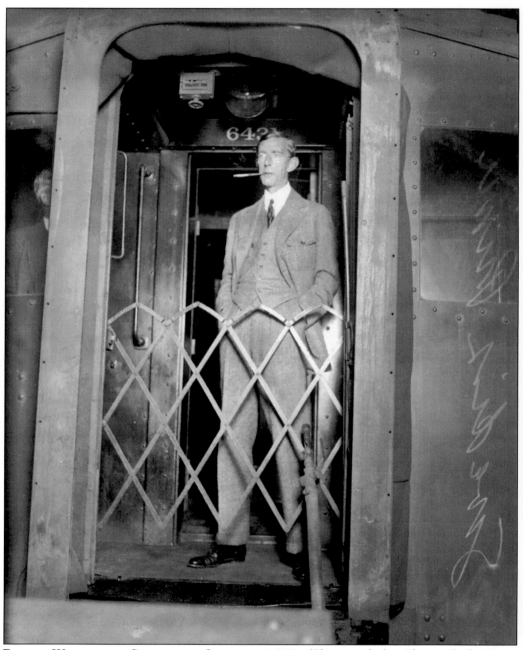

PRINCE WILLIAM OF SWEDEN IN CHICAGO, 1927. (Photograph by *Chicago Daily News*; courtesy of Chicago Historical Society, DN-0084133.)

CHARLES LINDBERGH, 1927. Although not a resident of Chicago, famous aviator Charles Lindbergh—who possessed Swedish roots—visited Chicago in the 1920s (a decade that welcomed the arrival of many Swedish immigrants). Here, Lindbergh addresses a massive crowd at Soldier Field in 1927. (Photograph by *Chicago Daily News*; courtesy of Chicago Historical Society, DN-0083861.)

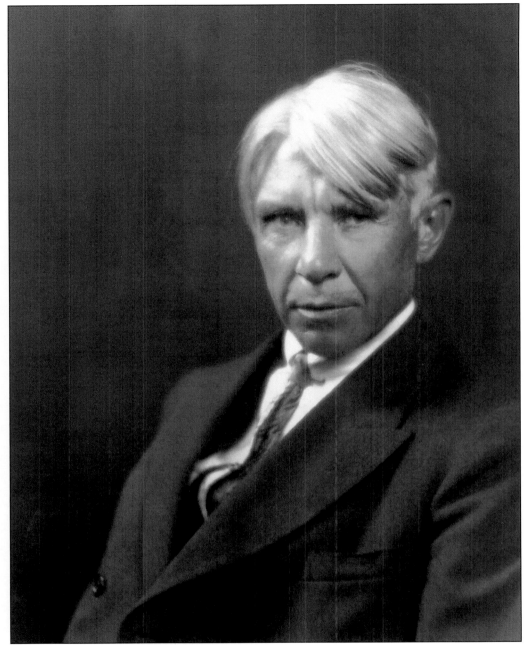

CARL SANDBURG (1878–1967). The writer, poet, and Lincoln biographer was born to Swedish immigrant parents in Galesburg, Illinois. In 1912, Sandburg moved to 4646 N. Hermitage Avenue (*opposite bottom*) and worked for the *Chicago Daily News*. It was in this house that Sandburg wrote his famous poem "Chicago." His collection of poems titled *Chicago Poems* was published in 1916. Because the house appears to have been rehabbed extensively since Sandburg's days here, a passersby may neglect to notice the historical placard adorning the front lawn that details Sandburg's literary achievements. (Photograph by Eugene Hutchinson; Courtesy of Swedish-American Archives of Greater Chicago, located at North Park University, Chicago, Illinois.) (Opposite: Photographs by Paul Michael Peterson.)

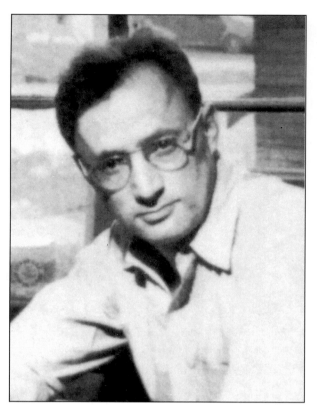

NELSON ALGREN (1909–1981).
Novelist and reporter Nelson
Algren—who wrote about the seedy
underbelly of life in books such as
Chicago, City on the Make and *Neon
Wilderness*—was born in Detroit,
but grew up in a poor immigrant
neighborhood on Chicago's South
Side. Algren's grandfather was
a Swedish immigrant who had
converted to Judaism, changing
his name in the process to Isaac
Ben Abraham. Algren, who
was educated in the Chicago
Public Schools, went on to study
journalism at the University of
Illinois. He earned a B.A. in 1931
during the Depression. (Photograph
courtesy of informational
placard, City of Chicago.)

ALGREN'S CHICAGO RESIDENCE. For
nearly 20 years, Algren resided on the
third floor of this building located at
1958 W. Evergreen Street in Chicago's
Wicker Park neighborhood. He
entertained many prominent writers
of his day in addition to developing
close friendships with Chicago writers
Studs Terkel and the late Mike Royko.
(Photograph by Paul Michael Peterson.)

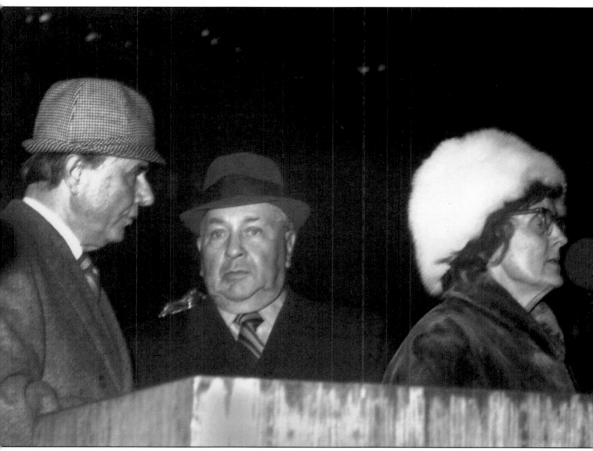

CHICAGO CIVIC CENTER, 1970. In honor of Swedish Lucia, Bo Janstedt, Mayor Richard J. Daley, and Swedish historian Selma Jacobson speak at Chicago's Civic Center in December, 1970. (Courtesy of Swedish-American Archives of Greater Chicago, located at North Park University, Chicago, Illinois.)

SWEDISH ROYALTY IN CHICAGO. On a visit to Chicago from Sweden, King Carl XVI Gustaf marches with Mayor Richard J. Daley in April, 1976. (Photograph by Philip Jacobson; courtesy of Swedish-American Archives of Greater Chicago, located at North Park University, Chicago, Illinois.)

KING CARL XVI GUSTAF. Flanked by Doris Swenson, Kurt Mathiasson, Consul General Karl Henrik Andersson, and an unidentified man, King Carl XVI Gustaf displays a plaque he received from the Andersonville Chamber of Commerce. (Photograph by Philip Jacobson; courtesy of Swedish-American Archives of Greater Chicago, located at North Park University, Chicago, Illinois.)

SELMA JACOBSON AT THE SWEDISH AMERICAN MUSEUM. Selma Jacobson proudly displays her book, *His Majesty Carl XVI Gustaf King of Sweden Visits Illinois*. (Photograph by Philip Jacobson; courtesy of Swedish-American Archives of Greater Chicago, located at North Park University, Chicago, Illinois.)

KURT MATHIASSON AND SELMA JACOBSON. Swedish community pioneers Kurt Mathiasson and Selma Jacobson (with unidentified man in background) review collected items for the Swedish American Museum. Note the chair pictured in the photo, which was handmade for Abraham Lincoln, but was never sold because of Lincoln's death. (Photograph by Philip Jacobson; courtesy of Swedish-American Archives of Greater Chicago, located at North Park University, Chicago, Illinois.)

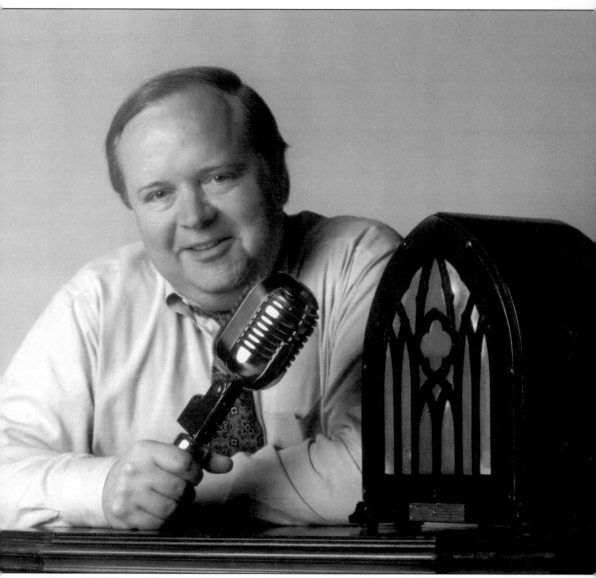

BRUCE DUMONT, CHICAGO RADIO PIONEER. Bruce DuMont, of Swedish ancestry, is known as one of Chicago's top broadcasters. As host of the radio program *Beyond the Beltway* he can be heard nationwide every Sunday night on more than 60 of America's major radio stations. In addition to myriad journalistic achievements on both television and radio, Bruce DuMont is the founder and president of Chicago's Museum of Broadcast Communications. (Courtesy of Bruce DuMont.)

THE MUSEUM OF BROADCAST COMMUNICATIONS, CHICAGO. Located in the Chicago Cultural Center on Michigan Avenue at Washington Street, the MBC is one of only two broadcast museums in America. Founded by Chicago broadcaster Bruce DuMont, the Museum is well known for its unique interactive exhibits that detail the history of radio and television. (Photographs by Paul Michael Peterson; courtesy of Museum of Broadcast Communications website.)

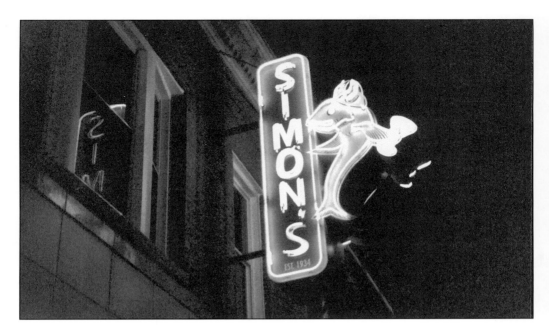

SIMON'S TAVERN. When Simon Lundberg started Simon's Tavern in 1934, he probably had no idea that he would end up creating "the anchor of Andersonville." Prior to owning the tavern, Simon Lundberg worked in the coal mines and later opened a restaurant a few steps away on Clark Street. After doing his share to combat Prohibition by serving whiskey in the restaurant coffee, Simon decided to open a tavern that catered to all of the Swedish laborers in the neighborhood. According to Simon's son Roy (pictured below), Simon's is layered with history. One fascinating aspect of the tavern is the small room underneath the stairs. Separated from the tavern by a thick wooden door with bulletproof glass, Simon employed this closet-like room for cashing bar patrons' paychecks on payday—a savvy business ploy that inspired the patrons to spend more on drink. Simon has long since passed away, and despite having a new owner, the Viking-helmet-clad neon fish holding a martini ("pickled herring") continues to attract many from far and wide. (Photographs by Paul Michael Peterson.)

Six

ARTS AND CULTURE

In a culture that prides itself on its painters, singers, and artisans, Swedes have much of which to be proud. Singing remained highly popular, especially in fraternal organizations such as the Svithiod Singing Club, the Orphei Singing Club, and today's Chicago Swedish Male Chorus. At the grand concert in Chicago's Orchestra Hall during the Century of Progress Exposition in 1933, Mr. Hjalmar Nilsson stated, "I would not be sure that Swedish ethnicity had died even if the Swedish language was no longer spoken in America, but I believe the end will come when Swedish songs are all forgotten." As of this writing, Chicago's Oriental Theater begins its run this month of *Mama Mia!*—the musical by former ABBA members Benny Andersson and Bjorn Ulvaeus. Whatever the future may hold, it seems clear that Swedish arts and culture will continue to leave a dominant, lasting impression on the audience to whom it caters.

DALA HORSE CARVING. The Dala Horse, a long-time symbol of Sweden, graces many Swedish homes as a decorative piece. Dating back to the 18th century, the unique folk tradition objects are hand carved and painted in Dalarna, Sweden. (Photograph by Paul Michael Peterson.)

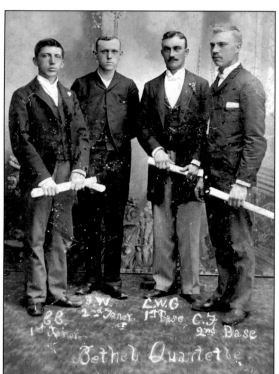

BETHEL QUARTET, C. 1890.
Demonstrating a firm commitment to music at the end of the 19th century was the Bethel Quartet, from the Swedish Evangelical Lutheran Bethel Congregation located in the Englewood neighborhood of Chicago. Carl Friberg—identified by the initials "C.F." on the far right—later became Charlie Freborg and is pictured earlier in this book. (Courtesy of Andy Freborg.)

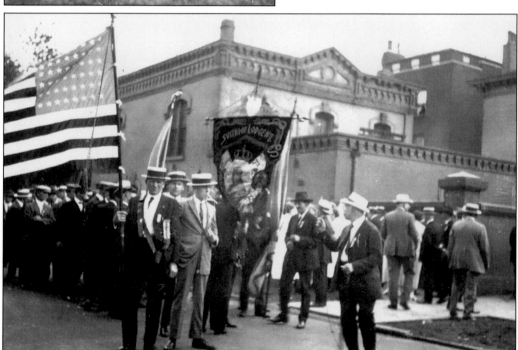

SVITHIOD LODGE PARADE GATHERING, C. 1929. Despite the looming Depression, many Swedish immigrants found time to participate in fraternal organizations such as the Svithiod Lodge pictured here. Charles E. Smith, a highly active member of the organization, proudly holds the American flag in this photograph. (Courtesy of Charles R. Smith.)

112

ORPHEI SINGING CLUB MEMBERSHIP CARD, 1964. (Courtesy of Bruce Peterson.)

SWEDISH MALE CHORUS GROUP PORTRAIT, 1976. (Photograph by B-J Rush Photo Studio; Courtesy of Swedish-American Archives of Greater Chicago, located at North Park University, Chicago, Illinois.)

AMERICAN UNION OF SWEDISH SINGERS CONVENTION BROCHURE, 1984. Hans Bolling—brother of Pehr Bolling—both of whom have been active members of the AUSS, created the cover art for the brochure pictured above. (Courtesy of Pehr Bolling.)

CHICAGO SWEDISH MALE CHORUS, CHRISTMAS CONCERT AT BETHANY HOME, 2001.
Pictured here are: (first row) Jim Ryan, Gunnar Seaberg, Jeff DeLay, Ray Helgeson, Bill Jones, and Wally Magnuson; (second row) Pehr Bolling, Wayne Nixon, and Don Swanson; (third row) Bob Voedisch, Kenneth Young, Jim Maurice, Paul Rimington, Gordon Johnson, Blaine Boogert, Alf Lundquist, and Bob Villvock. Hans Bolling and Sven Lindgren are not pictured. (Courtesy of Ray Helgeson.)

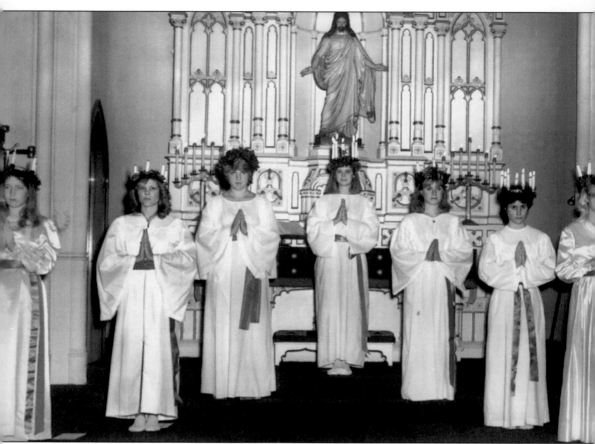

LUCIA CELEBRATION, C. 1981. This spiritually captivating photograph of seven young women honoring Lucia while posed in front of a church altar was taken in 1981. (Photograph by Philip Jacobson; courtesy of Swedish-American Archives of Greater Chicago, located at North Park University, Chicago, Illinois.)

INGER ABERG, *Whimsical Weavings* EXHIBIT, 2003. The Swedish American Museum Center hosted an exhibit of Swedish artist Inger Aberg's textile weavings in the spring of 2003. Utilizing children's drawings as the visual foundation for her textile weavings, Aberg's work offered museum patrons a unique perspective of warmth and innocence through art. (Courtesy of Swedish American Museum Center.)

The Swedish American Presents
a very special evening with Theo Ubique Theatre

The People, Yes

by Carl Sandburg
Thursday, April 24, 7 pm

The People, Yes, Carl Sandburg's transcendent anthem poem, is a soaring hymn to the common man. See it here in a chamber style performance, in which four actors play Sandburg's people: mothers, fathers, poets, farmers, politicians, and more. This acclaimed production was hailed as a "Critics Choice" by the Chicago Reader when it played at the Chicago Cultural Center in 2000.

This evening's production will be followed by a wine and cheese reception.
Cost: members $15, non-members $18.
Please call 773.728.8111, x 22 for reservations.

Swedish American Museum, 5211 N. Clark St., Chicago, IL 60640
www.swedishamericanmuseum.org

SWEDISH AMERICAN MUSEUM ADVERTISEMENT FOR CARL SANDBURG'S THE PEOPLE, YES. Sandburg's anthem poem was beautifully performed by four actors of the Theo Ubique Theater who effortlessly brought to life the Swedish-American poet's "hymn to the common man." (Courtesy of Swedish American Museum Center.)

RECEPTION FOLLOWING *THE PEOPLE, YES.* Museum volunteers and Theo Ubique actors mix at a reception following the stellar performance. (Photographs by Paul Michael Peterson; courtesy of Swedish American Museum Center.)

BANNER, BROTHERHOOD OF PAINTERS, DECORATORS, AND PAPERHANGERS OF AMERICA, LOCAL NO. 637. (Courtesy of Collection: Swedish-American Archives of Greater Chicago, located at North Park University, Chicago, Illinois.)

Seven

PRESENT DAY

Driving north on Clark Street from Foster Avenue, one will notice a potpourri of cultures and ethnic storefronts. Although the once-famous Swedish businesses retain the original names on vintage marquees and fading awnings, new owners have arrived to assume command and thrive in the new gentrified economy. And while "Andersonville"—the Scandinavian nomenclature for Edgewater's cultural gem to the east—struggles to retain its once-great Swedish heritage, a few remaining holdouts continue to survive and in some cases, flourish.

The Swedish-American Museum Center, a bastion of Swedish history and culture, offers a rich sense of scholarship and community to those who pass through its doors. The delicatessens and eateries, once flanked by Swedish immigrants in standing-room-only positions, console themselves with the twice-a-year financial boom brought about by the visiting masses at Christmas and Midsommarfest. Chicago telephone books—honeycombed with surnames such as Anderson, Gustafson, Nyholm, and Swedborg—testify to the city's lingering Swedish presence. And the children and grandchildren of Swedes who once formed the nucleus of our fair city now occupy the margins and dot the corners of more pastoral communities known as Geneva, St. Charles, and Bishop Hill.

But I leave you with this promise: if you listen while sipping your glögg in the icy depths of December's chill, you can hear the echoes of Sandburg and Algren; and while you gleefully cheer for our Chicago Cubs when Wrigley Field seizes you in its humid grip, you can feel the legacy of Lanquist; and as you take your place on the "el" trains and buses among the many denizens making their daily commute to work, you can sense the spirits of the builders, the painters, the bakers, the machinists, and the laborers who sweat, and toiled, and breathed their legacy into the invisible, but-always-present Viking mosaic that some of us fondly refer to as "Swedish Chicago."

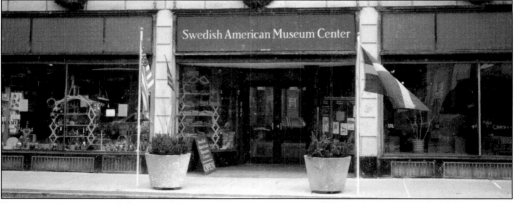

SWEDISH AMERICAN MUSEUM CENTER EXTERIOR, 2003. (Photo by Paul Michael Peterson.)

SWEDISH BAKERY, 2003. Although no longer under the original Swedish management, the Swedish Bakery continues to pack them in. Residents and visitors rely on the large selection of breads, cakes, and pastries to complement even the most basic of celebrations. (Photograph by Paul Michael Peterson.)

CHARLIE'S ALE HOUSE, 2003. Reflecting the masses of gentrification in a rapidly evolving neighborhood, Charlie's Ale House is one example of a sophisticated consumerism replacing the familiar and traditional storefronts in which neighborhood residents and Swedes once took solace. (Photograph by Paul Michael Peterson.)

PREPARING FOR MIDSOMMAR CELEBRATION, JUNE, 2003. Pictured, from the left, are Anna Dupont, Katharine Chandler, Kristin Rimington, and Marie Bolling. They are preparing cut flowers at the Swedish American Museum for the upcoming Midsommar celebration. (Photograph by Paul Michael Peterson.)

SWEDISH-AMERICAN ARCHIVES OF GREATER CHICAGO, NORTH PARK UNIVERSITY'S BRANDEL LIBRARY. Established in 1968 by the Swedish Pioneer Historical Society (later re-named the Swedish-American Historical Society), the Swedish-American Archives of Greater Chicago offers a virtual treasure chest of archival material related to the Swedish experience in Chicago area. Ellen Engseth, director of Archives and Special Collections for the SAAGC, offers a knowledge of Swedish archives unrivaled in scope by anyone I've encountered in six months of preliminary research. (Photograph by Paul Michael Peterson.)

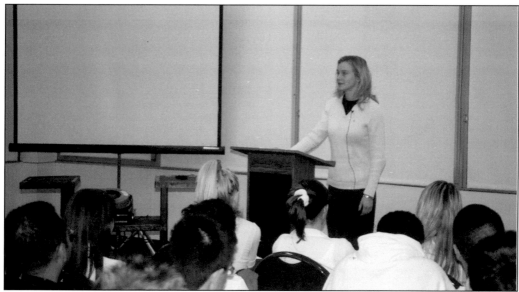

SWEDISH EXCHANGE STUDENT VISITS TAFT HIGH SCHOOL, 2003. North Park exchange student Therese-Marie Malm spoke to students enrolled in Taft High School's International Baccalaureate Program. Celebrating an I.B. tradition known as "International Week," Miss Malm educated students with information about Sweden's culture and economy. (Photograph by Paul Michael Peterson.)

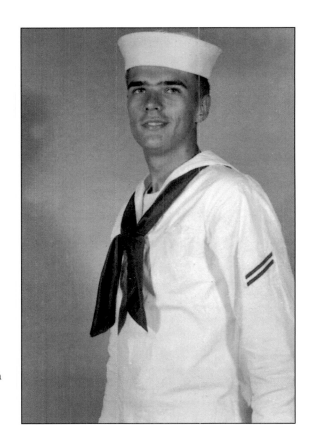

TWO GENERATIONS OF SWEDISH-AMERICANS. Chicago resident Jim Thorson (pictured below), a science educator and member of the U.S. Naval Reserve, followed in the footsteps of his father, Ronald (above), when he decided to serve his country. Although originally from Rockford, Illinois—another Swedish enclave outside of Chicago—Jim now makes his home in the city. (Courtesy of Jim Thorson.)

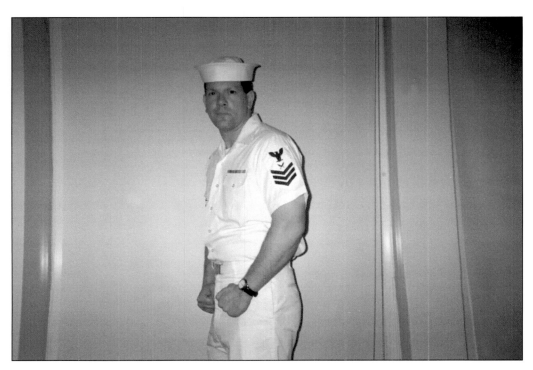

MAMA MIA! Chicago's Oriental Theater hosts a production of *Mama Mia!*—a musical by former ABBA members Benny Andersson and Bjorn Ulvaeus. (Photographs by Paul Michael Peterson.)

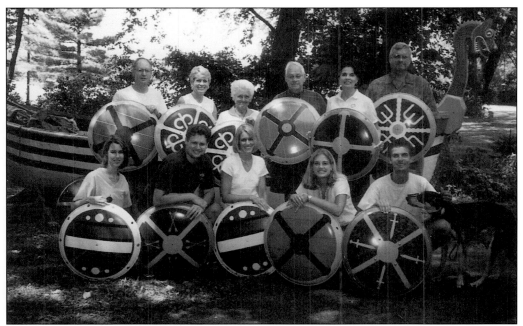

THE PEHR BOLLING FAMILY. Enjoying the clean, fresh air at Lake Marie, the Pehr Bolling family poses for a group photograph. Pictured, from left to right, are: (back row) Paul Rimington, Barbara Rimington, Harriett Bolling, Pehr Bolling, Birgitta Bolling, and Tom Bolling; (front row, kneeling) Amy Rimington, Robert Rimington, Kristen Rimington, Marie Bolling, and Carl Bolling. (Courtesy of Pehr Bolling.)

PAUL MICHAEL PETERSON AND PEHR BOLLING, BARNES AND NOBLE, DEERFIELD, 2003. "You don't look like a Swede!" were Mr. Bolling's first words to me upon meeting each other. I found the man to possess a warm and professional nature, complemented by a strong work ethic—a symbol of the Swedish immigrants about whom I've been striving to learn. (Courtesy of Paul Michael Peterson.)

150 N. Michigan Avenue. The diamond-shaped building in the center background headquarters the Consulate General of Sweden and is home to the Swedish Trade Council. The Swedish presence in Chicago is alive and well among the high rises of the Magnificent Mile. (Photograph by Paul Michael Peterson.)

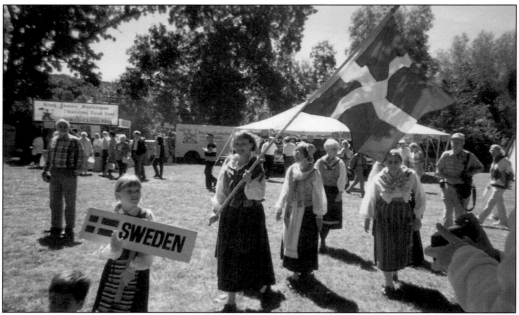

Swedish Days, Geneva, Illinois, c. 1992. Approximately 50 miles west of Chicago, one can experience the culture and flavor of Sweden in the bucolic setting of Geneva, Illinois. An inviting community of 19,000, Geneva celebrated the 50th anniversary of its Swedish Days festival in 1999. (Photograph by Paul Michael Peterson.)